Ted Turnau is Chair of Literature and Culture at Anglo-American University, Prague, Czech Republic, where he also teaches on popular culture, the media, religion and social theory. He is the author of *Popologetics: Popular culture in Christian perspective* (P&R, 2012), *The Pop Culture Parent: Helping kids to engage their world for Christ*, with co-authors E. Stephen Burnett and Jared Moore (New Growth, 2020), and *Oasis of Imagination: Engaging our world through a better creativity* (IVP, 2023). He speaks widely on popular culture, the media and Christian cultural engagement. He and his wife Carolyn have three adult children, three cats and a rabbit.

Ruth Naomi Floyd is a vocalist-composer who has been at the forefront of creating vocal jazz settings that express theology and justice for more than 25 years. She leads her own multifaceted ensemble and her recordings consist primarily of original compositions. Ruth lectures on the intersection of beauty, theology, justice, culture and the arts, primarily in the USA and the UK. She is also a photographer, specializing in black-and-white portraiture, and is a committed educator and justice worker.

'This is the imaginative manifesto the church needs! For creatives struggling with feeling misunderstood and invisible. For churches who want to engage with their creative folk and culture but feel afraid or out of their depth. This book is it!

'It is funny, self-deprecating and insightful: something I wish the younger me had been able to read, when I was fresh out of an environment that saw pop culture as something to be feared and protected from.

'It can act as a guide to parents on why we want to equip, not shrink-wrap, our young people. It shows the value of sitting with the discomfort and the weight of the questions that art can bring.

'It also has great practical tips for churches and individuals on supporting their creatives because, as Ted and Ruth so clearly show, the church and creatives need each other.'
Sophie Killingley, artist and writer

'For many years, I have been deeply grieved that conservative Christians in the English-speaking world have tended to undervalue, or even disdain, the arts and artists. This book is the most engaging and persuasive argument I've encountered for why the church needs artists and why artists need the church. Reading this was a total joy.'
Tony Watkins, Fellow for Public Engagement, Tyndale House

IMAGINATION MANIFESTO

IMAGINATION MANIFESTO

A call to plant oases of imagination

Ted Turnau and Ruth Naomi Floyd

INTER-VARSITY PRESS
c/o SPCK, RH101, The Record Hall, 16–16A Baldwin's Gardens, London EC1N 7RJ,
England
Email: ivp@ivpbooks.com
Website: www.ivpbooks.com

First published 2023

British Library Cataloguing-in-Publication Data
A catalogue record for this book is available from the British Library.

ISBN: 978–1–78974–473–6
eBook ISBN: 978–1–78974–474–3

Set in Minion Pro 10.25/13.75pt
Typeset in Great Britain by CRB Associates, Potterhanworth, Lincolnshire
Printed in Great Britain by Ashford Colour Press Ltd, Gosport, Hampshire

Produced on paper from sustainable sources

*Inter-Varsity Press publishes Christian books that are true to the Bible and that
communicate the gospel, develop discipleship and strengthen the church for its mission
in the world.*

*IVP originated within the Inter-Varsity Fellowship, now the Universities and Colleges
Christian Fellowship, a student movement connecting Christian Unions in universities and
colleges throughout Great Britain, and a member movement of the International Fellowship
of Evangelical Students. Website: www.uccf.org.uk. That historic association is maintained,
and all senior IVP staff and committee members subscribe to the UCCF Basis of Faith.*

Ted

For Carolyn, as beautiful and creative a soul
as I've ever been blessed to know

Ruth

For Kenyatta, the most precious soul in my creative life

Contents

Foreword

Reading *Imagination Manifesto* is to be transported to the halls of a favourite gallery, captivated by a jazz concert or entranced in a Japanese anime. Indeed, Ruth and Ted's love of the arts is matched only by their sincere faith and intelligence in bridging the gaps between faith and arts communities.

I admit, when first asked to write a Foreword for this book, I hesitated. Does the world need another manifesto right now? In a global moment so marred by toxic politics, invasions, occupations and cultural striations, the very thought of a manifesto seemed unnecessarily didactic or divisive. Yet Ruth and Ted offer something very different to the aggressively pedantic prose I have come to associate with the language of manifesto. More fool me, *Imagination Manifesto* is a generously expansive conversation concerned with healing cultural rifts. It punches a fist to the air but an olive branch is clasped within. Placards of protest rise but their slogans are a banner of love. Indeed, *Imagination Manifesto* is deliciously paradoxical, demanding both exhortation and acceptance, aspiration and lament; a kind of hearkened resistance, witty, wise and practical in exploration of a timely subject, and a welcome addition to the ongoing conversation about faith and the creative arts.

This book is about creative cultural engagement, something Ruth and Ted liken more to a covenant of love than a strategy of war. It reads like a conversation between friends, moving between rhetorical argument, parable, words of encouragement, theological insight and anecdote. At times I welled with tears, being especially moved by Ruth's account of an art critic who sought reconciliation with a friend after viewing her photographs.

In moments, it reminded me of Corita Kent's ten rules for art students and teachers, also developed through many years working with artists and understanding their needs. In other moments, it brought to mind the letters of Van Gogh to his brother Theo as he wrestled with his art in relation to his faith. At times, I felt as if I were reading a film script or letter from a mentor. In this way, Ted and Ruth speak to a broad demographic of practising artists, aspiring creatives, church leaders and those who wouldn't consider themselves artists but want to support those who do. The closing chapters are especially helpful in offering practical encouragement to both the artist and 'the rest of us', as Ted puts it. Each chapter ends with questions for further discussion, a helpful tool for students, book groups or personal reflection. I laid down my copy periodically to pick up my sketchbook and make notes or drawings in response to what I had read.

Ruth and Ted offer definitions for terms such as culture, engagement and imagination that are often surprising; culture is a jazz ensemble or a network of things that can bind us together or drive us apart. Imagination is a fish, or a pair of spectacles with coloured lenses, or an unruly kid who sits in the back of the classroom and doesn't always follow the rules.

Ted argues that culture is not optional because it is both God's command and human nature. As such, it is worth engaging because it may well be around for ever. He winsomely debunks often-held assumptions that God is angry with creative culture or will burn it up when Christ returns. We are reminded that Jesus calls us to be culturally active in every area of society, not just to be passengers in the world but called further into it, to be deeply resonant in the cultural fabric of creation.

Imagination Manifesto describes a kind of collective church aphantasia, where certain Christian communities have dismissed the imagination as something suspicious or irrelevant to mission. Yet, as Ted puts it, dismiss the imagination and you end up dismissing most of the Bible.

As an artist, I have vested interest in all things related to imagination. Current research in cognitive science suggests that our imagination isn't solely connected to sight. The visual cortex isn't the only region of the brain that's responsible for powering imagination, and certain scientists hypothesize that imagination is the result of a holistic neural network that coordinates activity across the brain, including our neural responses to touch, taste, feeling and even pain. In this way, imagination may not wholly exist in the mind. It may also be encoded in our bodies. This shouldn't come as too much of a surprise and evidence suggests that our ancestors imagined as such. The Hebrews imagined from their gut, the Greeks from their heart. A biblical understanding of the imagination encompasses body and mind, something more incarnate, even fleshy material. It is only more recently that we have come to consider the imagination an occupation between the brain and eyes. When I paint, I'm not merely engaged in a cerebral activity but one that involves my arms, hands, touch, sense, emotion, intuition, repeated behaviour, habit and improvisation. In this way, my imagination doesn't stand independent of my body but is profoundly interconnected from neural pathway to sinew and muscle. I don't just imagine from my mind's eye but through my entire body.

Imagination may also inform the daily rhythms of living, moving and navigating the world, through the regular rituals of moving across a room, driving a car, reading the Bible, playing guitar, preparing breakfast and even sitting in a pew. Each of these cultural activities is a form of embodied imagination that informs who we are and what we think and believe. Imagination matters because it informs every aspect of human life. If I am to take captive every thought and make it obedient to Christ, I must submit my imagination to the Lordship of Christ as an act of daily devotion. In this way, Ted and Ruth do a great service to all who seek to understand how imagination can be consecrated in a life devoted to Christ.

Foreword

Described in two aspects, creative and perceptive, *Imagination Manifesto* argues that the imagination shapes our experience of the world around us, and enables us to bring new things into the world with the power to shape us and how we perceive reality. Ruth and Ted invite us to nurture both a cross-shaped imagination that deals with darkness, and an empty-tomb-shaped imagination that helps us to live in the light, or indeed to embrace both in tension.

Imagination Manifesto is a bold, compassionate and empathic readdressing of an imbalance that has existed for many years. It reunites reason with imagination with such clarity of purpose and strength of vision that it cannot help but inspire. It will make you reach for your paints, march for injustice, pen a love song, write to your pastor and sing out a new song of praise. Ruth and Ted's vision is necessary because it's how we were intended to live. This manifesto matters because imagination matters and no better guides could be granted in this journey than Ruth and Ted.

Alastair Gordon
Co-founder of Morphē Arts and a painter and art tutor
at Leith School of Art

Acknowledgments

Ted

I would like to thank Claire Elise Turnau Ward for allowing me to tell her story. I would like to thank the artists (some of whom are named in *Oasis of Imagination: Engaging our world through a better creativity*, IVP, 2023) who shared works that inspired me. Some shared personal stories that lit a fire under me to write both *Oasis of Imagination* and this book. And I would like to thank my wife, Carolyn, my kids – Roger, Claire and Ruth – and so many friends who encouraged me to write and prayed for me.

Ruth

I thank my dear departed parents, the Reverend Melvin and Elizabeth Floyd, and the late Gregory Mobley, for nurturing and supporting my musical gifts. I want to thank Lois Olga Fox, my beloved aunt, who, when I was a child, inspired me to become a visual artist.

Introduction: why a manifesto for the imagination?

To address the disconnect between church and world

People write manifestos when the world they see is out of kilter somehow. When there's a significant disconnect between the way the world is and how it ought to be, that's when you get out a pen (or laptop) and lay out an alternative vision, a change of direction.

There is a disconnect between church and world. It's a perennial problem, an age-old tension between Christians and the world they live in. But in the past few decades, it has got worse. You will no doubt have noticed the church change roles over the years, from a cultural authority and trusted friend to an irrelevance, even an enemy. This is not good news, for the ones estranged from the church need what the church has to offer: the true good news. The church's response to this new situation has itself been out of kilter in certain ways. Hence the need for a manifesto.

'Manifesto' is a scary word for some. It summons up visions of scruffy, long-haired, bespectacled students preparing for the latest revolution. Wild-eyed activists marching or building barricades. Violence. Weapons. Guillotines. Rest assured, this book is not that, though one of us *is* bespectacled (Ted) and the other rocks an amazing afro (Ruth).

We chose the word 'manifesto' because it is like an alarm clock, to awaken Christians to the problem and to a potential solution: the imagination and creativity that lies within the church community, right under our noses. If we ignore the life of the imagination, we will watch the alienation between the church and the surrounding

culture deepen. We will look on, befuddled, as more and more Christian creatives grow discouraged and restless within the church, many heading for the exit. We need to pay attention to the imagination, for it holds the potential to heal the rifts that divide us. Cultivating imagination can help build bridges into the culture we all share. That is what this book is about: creative cultural engagement.

Harmony, dissonance and improvisation with the music of culture

What do we mean by 'culture'? Culture is a network of things, institutions, values and patterns of behaviour that binds us together . . . and sometimes drives us apart. Culture is like a jazz ensemble. It depends on many different contributors working in harmony – a family holiday tradition here, an architect there, a university prof. discussing issues with his students, a government official crafting policy, a nursery nurse caring for toddlers in a day nursery, a caretaker sweeping a hallway. All of them follow (more or less) a 'score', a set of agreed-on rules that determine the 'key' that they 'play' in, the rhythm of their lives. There are, of course, injustices, crimes, things that cause static and pain. But in any functioning society, the culture follows the score – a shared picture of the world that guides how we move and act in it. Oh, but then there are these creative types who – without breaking utterly away – play jazz. They *improvise* on the score, elaborate on it, deepen it, make it shimmer and vibrate in a new way. Sometimes, they intentionally add notes of dissonance, not because they are ignorant of the overall music of culture, but because they want to protest that which is dark, wrong, predatory to human dignity, an enemy of *imago Dei*. And sometimes, they can even end up rewriting the score a bit.

Once upon a time, the church was very much in charge of the score. It set the rhythms of life, set the standards for what counted

as fair and good, and generally laid the order of the world out for all to see. That age has passed. The age of church-as-composer is over; we live in a post-Christian world. How did the church respond to this shift in the way that the orchestra functions? Well, some clung to dreams of past glory and tried to force their way back into the conductor's seat. And when they were rebuffed, they blew their horns from the sidelines, furious at and fearful of what was to come. Others decided that enough was enough and they left to form their *own* orchestras, carefully insulated from the mainstream. They tended to copy the mainstream a bit, but in a different key, and with tunes that grated terribly on the ears of those outside their own group.

We would like to suggest another way, a path that contributes to *and* challenges the mainstream, a path that does not glory in being out of tune with the mainstream. 'But shouldn't Christians aim to be out of tune? Isn't that part of our Christian distinctiveness? Our light before the world?' Yes, but play too far out of tune and you come across as hateful, as a musical vandal. Jazz, the quintessential improvisational music, is not vandalism. It was birthed in protest against oppression that distorted human dignity. But it did so in a way that made it impossible to ignore its creative contribution to the culture.

Christians who want to contribute and engage mainstream culture must learn to *improvise* new tunes that harmonize and some-times artfully conflict with the orchestra, draw in others who don't share our faith, tunes that reveal a tension between the status quo and a new creation, music that opens up strange new landscapes for imaginations to explore.

A parable about creative cultural engagement

Let us illustrate what we mean with a story, a parable.

The parable of the oasis that was really a portal to another universe[1]

Once upon a time, there was a traveller who habitually trekked throughout a dry and hostile land. It didn't bother him much, for it was all he knew. One day he saw in the distance a patch of greenery. That much colour in a land of unbroken dust-brown enticed him, and he set out for it. As he drew closer, the patch of green revealed more detail to him. This was a place of tall trees, lush undergrowth, and wild flowers.

He entered into the shade. In the centre of the oasis, he found a still pool of crystal-clear water.

But he found he was not alone, for there was a man across the pool from him, staring intently down into the water.

The traveller enquired why the man was staring so. Perhaps he had seen a fish? 'No,' the man replied. 'No fish. Something more remarkable. See for yourself.'

The traveller stared intently, too, and saw something glimmering at the bottom of the pool. It might have been simply the shimmering sunlight refracted on to the rocks below. But no, it was something more. He couldn't see it clearly, but he found the light mesmerizing. It fascinated him in a way that he could not put into words.

He cautiously asked the man across the pool about the glimmering light, what he thought it was. They talked about it until the sky grew dark and it was time for the traveller to move on.

But he was so intrigued that he came back the next day, both to gaze into the pool and to continue his conversation with the stranger. The stranger had brought food, so they shared a meal together as they continued talking, sharing ideas and theories about the mysterious light at the bottom of the pool. The traveller

resolved to return again the next day. And so he did. This became his habit for some time.

Gradually, he found that he had become more and more dissatisfied with the dry and hostile land. He much preferred the cool shade of the oasis and the company offered there. Eventually, the stranger lost his strangeness and became a trusted friend and discussion partner.

And all the while, the light at the bottom of the pool came more and more into focus, as if someone were adjusting a hidden lens. Whole cities full of light and life began to take shape before his unbelieving eyes. The traveller knew it was impossible, for cities do not reside at the bottom of ordinary pools. Nevertheless, he continued to study the image. He sensed in it a piercing beauty that entranced and drew him magnetically, almost more than he could bear. He loved his time gazing into the pool. And yet he felt a profound sadness, for the light stirred in him deep grief as well as deep gladness.

It became increasingly obvious that this was no ordinary pool. It was rather a doorway to another world, another way of being. It also became clear that the man who had been a stranger and was now his friend had in effect become his guide. It was only a matter of time before the traveller would take the plunge to the bottom of the pool to begin the most improbable, miraculous journey he could have ever imagined.

This is what good cultural creativity can do: invite Christians and non-Christians alike into a space where their imaginations can be refreshed, stretched, challenged and comforted. Creative works in the arts and entertainment can provoke conversations and exploration. Such works can build bridges and close the gap between churches and a deeply suspicious or apathetic world.

Imagination as a fish

But to get there, we need a better understanding of the imagination.

The imagination is like a beautiful fish, lurking in the shadows of a kelp forest. You want to touch it, grasp it, hold it. But it's elusive. In a flash of sunlight and multicoloured scales, it evades your hand and swims away to lurk somewhere else. But smart divers know to bring bait – a defrosted prawn, a bit of calamari – so it will come to them. If you do this regularly, too, it will grow used to you, become a friend. You will perhaps be able to share its magnetic beauty with others.

Consider this manifesto as your defrosted prawn, a way to better understand and befriend this elusive, alluring thing we call imagination, so that the church itself will present a more alluring witness to a watching, suspicious and deeply needy world.

We have nothing to lose but the chains that bind our imaginations. We have a world to winsomely invite to Christ. Christians of the world, unite![2]

P.S. from Ted

This book is a companion volume to a bigger book I wrote called *Oasis of Imagination: Engaging our world through a better creativity* (IVP, 2023). It's rather . . . large. IVP thought that some of you might be put off by a thick book with a lot of footnotes. So they asked me to write a smaller, more accessible book and to bring in an artist who could contribute some personal experience and practical know-how that I lack. Ruth was my first choice. Not only is she an accomplished jazz vocalist, lyricist, composer and photographer, but she has also always struck me as having a heart that is wise, humble, generous and keenly focused on the glory of God.

I took the lead in chapters 1 to 6, the nerdier, more theoretical/ theological stuff, and Ruth took the lead in chapters 7 and 8, where she could bring her practical wisdom about art to bear on the content.

We shared the Conclusion. Throughout the writing process, we have made suggestions and tweaked each other's sections. Truth be told, Ruth has made this book better than I could ever have done alone.

If you read this book and want to see some of the arguments fleshed out more, you want to see the receipts, a deeper meditation on what the Bible has to say about the imagination, some of the science and philosophy behind what's being said here – in short, if you're kind of a nerd like me – then, by all means, grab a copy of the big book as well. It is my hope that your further questions will be answered there.

Enjoy!

P.S. from Ruth

I was surprised and deeply grateful that Ted asked me to share in this book. His insight, intellect, research and experience make this book possible. I am fascinated by manifestos, particularly manifestos written by creatives and artists. This creatives' and artists' manifesto is here to define and critique the present-day art and culture and to provide a creative concept that can shift the current paradigms. This deeply resonates with me. If to create is to protest all that is wrong and unjust, then the imagination manifesto shows how artists and creatives can communicate about and persuade culture through the arts.

Notes

1 This parable also appears in the companion to this book by me, Ted Turnau, *Imagination Oasis: Engaging our world through a better creativity* (IVP, 2023).

2 This is a riff on the famous ending of that most celebrated and condemned manifesto, Marx and Engel's *Communist Manifesto*, <www.marxists.org/archive/marx/works/1848/communist-manifesto/ch04.htm>, accessed March 2023. Fear not – it's a parody, not an endorsement, of communism.

Imagination manifesto

1 *Jesus calls us into the world, so we should engage culture.*

2 *Jesus calls us to love and serve our neighbours. Stop undermining this calling by fighting culture wars to impose 'Christian values'.*

3 *Jesus calls us to seek the good of our communities, so we must build bridges rather than retreat into 'safe' Christian bubbles.*

4 *We need to plant oases – creative works that invite Christians and non-Christians alike into conversation.*

5 *Imagination is an important part of how God made us. We need to understand how 'the eyes of the heart' shape both how we perceive the world and how we create new worlds.*

6 *A Christian imagination that plants oases in a post-Christian world must express the tension between the darkness and the light, and find a proper balance and resonance between shouting its message and mumbling incoherently.*

7 *Christians are called to be witnesses, to bear witness both to darkness and to light, to the realities of life's joys and challenges and to our hope in Christ.*

8 *Artists in our community bear witness, enriching our imaginations with their creativity. We, in turn, should bear witness to them by supporting and nurturing the artists and creatives among us.*

9 *Christian artists need the church, and the Christian community needs artists. Christians of the world, unite!*

1
Why engage culture?

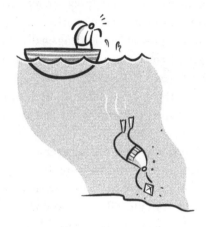

Jesus calls us into the world, so we should engage culture.

Cultural engagement is an essential part of following Jesus. Not everyone engages in the same way or to the same level, but it is an issue that ought to be on every Christian's radar. Embraced, not avoided.

But what is cultural engagement?

'Engage' as in 'relationship' or 'conversation', not as in 'launching a military attack'

When some people hear the phrase 'engaging culture', they imagine that it means firing salvo after salvo of hot takes, meant to get your point across and stick it to your enemies.

Let's just get this out of the way at the outset: we do *not* mean that. We are not encouraging an escalation of the 'culture wars' that go on. We don't think that Jesus wants us to have enemies we fire salvos at.

Rather, we mean something akin to engaging a friend in conversation and engaging in a really satisfying occupation, engaging your heart and mind in something that matters.

Or think about the phrase 'getting engaged' – the thing you do before you get married. In this case, 'engaged' means 'I am committed to you because I love you.'

Engagements cost the engager something – a ring, a nice dinner, time to go for a walk at sunset. You spend a bit of yourself on behalf of the engagee.

That is what we mean by 'cultural engagement' – investing something of ourselves, our time and treasure, into the culture that we share with others because we love them. It means that we are willing to involve ourselves in the cultural conversation happening in the arts and entertainment because we want the world to be a better place, to express something of God's shalom, his call to peace and human flourishing. Not a call to war, but a call to caring self-investment on behalf of others.

Of course, the opposite of being engaged is being *dis*engaged, disconnecting yourself from those around you, blinding and deafening yourself to a needy world. We are convinced that this is not God's good plan for us and for our world.

What does cultural engagement look like? It can take a number of different forms. It might mean going to a pub or club with non-Christian friends, not necessarily to evangelize, but to understand a bit of their world better and so understand them better (which will obviously help if an evangelistic conversation arises in the future). It might mean watching a Japanese anime or listening to electronic dance music simply because your kids enjoy it, so that you'll be able to discuss it intelligently with them. It might mean watching that

movie or television series everyone's talking about and really thinking about what it means and how it relates to your faith.

Or it might mean – and this is our focus in this book – creating something that adds beauty and depth to the world, something meant for non-Christians as well as Christians to enjoy.

In case you remain unconvinced that Christians *should* engage the culture around them, let us give you a few additional reasons – propositions, if you will. If you are convinced of the importance of engaging culture yourself, but other Christians in your church or context aren't yet persuaded, these might also be helpful starting points for opening up gracious conversations about why culture should matter to Christians.

Culture is not optional because it is God's command *and* human nature

The first and most obvious reason to get involved with culture is that God commanded it and created us to be like him: creators. The difference is, God made his amazing creation from nothing, whereas we use the amazing things God made to create . . . culture.

That's really the simplest way to think about culture: stuff we make from the stuff God has made; creation reconfigured.

A painting will use pigments made from earth and plants and oils. A musician will make music from his breath pushed into a horn made of metal. A journalist writes stories using ink (oils, pigments and chemicals synthesized eventually from naturally occurring substances) and paper made from pulp from trees. Or he uses a laptop made from metal, plastic (a petroleum product), silicon and rare metals mined from the earth. Even a singer uses God-made muscles and vocal chords to produce vibrations in God-created air.

Of course, culture isn't just stuff, physical objects. Culture is about the *relationships* between people and between things. Patterns of behaviour and belief form around those relationships. A dinner table

becomes the place for a family to gather and talk with one another.
A school building becomes a place for the formation of young minds
(and, perhaps, a battleground over what is taught there). But all of
these things – institutions, habits, attitudes, values – can be traced
back to the stuff God made, including the human spirit that breathes
life into the stuff as we make and use them. In a mysterious and
powerful way, our creativity mirrors God's.

Just listen to what the Bible has to say about God's creation of the
first humans:

> Then God said, 'Let us make man in our image, after our
> likeness. And let them have dominion over the fish of the sea
> and over the birds of the heavens and over the livestock and
> over all the earth and over every creeping thing that creeps on
> the earth.'
>
> So God created man in his own image,
> in the image of God he created him;
> male and female he created them.
>
> And God blessed them. And God said to them, 'Be fruitful and
> multiply and fill the earth and subdue it, and have dominion
> over the fish of the sea and over the birds of the heavens and
> over every living thing that moves on the earth.'
> (Genesis 1:26–28)

Does it strike you as odd that this little human-creation poem is
sandwiched between a repeated command: 'have dominion'?

It's a clue that our creation in God's image is bound up with that
dominion/ruling/being fruitful activity that God called our first
parents to. Theologians call this the 'Cultural Mandate' – that is,
God's call on us to go and make good use of his creation. Just as God
is Lord of all the earth, he has appointed us to rule and develop his

creation, to bring out its beauty for his glory – sort of acting like substitute parents to the things of this earth. We're not called to be tyrants or exploiters of the earth, but to be stewards, sub-kings under God's authority, and to act like kings were always *supposed* to act: to lovingly guide and nourish their subjects to make the kingdom shine like a precious jewel.

The Bible, from the very beginning, sees cultural development as part of God's plan. We need not be afraid of culture, even cultural traditions that are unfamiliar to us. There is a real virtue in sitting at the feet of other cultures and learning from them. After all, cultural diversity was always part of the plan. God forced the issue when he fractured the common language into new language groups at the Tower of Babel (Genesis 11:1–9), creating, in essence, new cultural communities. It is also telling that when Peter preaches after Pentecost, everyone hears his words 'in their own language' (see Acts 2:6–12). God didn't erase language diversity in his church, and he didn't erase cultural diversity either. Rather, he used them as channels through which the gospel could and did spread.

Consider Paul, the church's greatest missionary, in Acts 17. He uses Greek poets to talk about the true God. Or consider his Letter to the Philippians, where he uses concepts such as 'citizenship', which he knew would resonate with his readers, to tell them of their true home, their 'citizenship in heaven', in Philippians 3:20. 'Citizenship' is not a Hebrew concept, but a Greco-Roman one. His list of virtues in Philippians 4:8 ('whatever is true, whatever is noble, whatever is right, whatever is pure . . .' (NIV)) contains words gleaned not from the Old Testament, but from classical virtue lists that he learnt as he studied Greek culture.[1] Paul's famous phrase, how he has become 'all things to all people, that by all means I might save some' (1 Corinthians 9:22), absolutely included engaging the cultures of the people he wished to reach. Cultural diversity should excite us, not put us off. The gospel flows through cultural channels, saving some.

And in the future, God's plan is not only the preservation of culture in general (as we shall argue below) but also the preservation of different cultures. The great multitude unveiled in Revelation 7:9 is composed of 'every nation, tribe, people and language, standing before the throne and before the Lamb' (NIV). They are united in worship, but they still have their cultural distinctiveness. The Bible is a thoroughly pro-culture book, from soup to nuts.

God calls us to engage our world creatively, culturally. He's put it in our DNA, implanted it in our desires. We will create and enjoy culture one way or another.

The real question is: will we be intentional about it?

Will we do so wisely, in a way that loves and serves our non-Christian neighbours and secular communities?

Or will we hide our light under a bushel and keep our creativity to ourselves, disengaging from the cultural conversations going on around us?

Culture is worth engaging because it may well be around for ever

Some Christians have the sneaking suspicion that the culture around them isn't worth engaging because it simply won't last. Isn't the book of Revelation – not to mention prophetic books such as Isaiah – full of images of fiery destruction? Won't this old, tired, dirty world of pollution and porn be wiped away to be replaced by a pristine new one? Isn't evangelism – saving people so that they can share in the world to come – a much more urgent priority than cultural engagement, *especially* since God will destroy the first creation?

That's conventional wisdom in some circles, but the Bible gives a much more nuanced, complicated picture. Since we are talking about the end times, the Bible does not reveal all the details. But it does give us some enticing clues about the survival of culture into the new creation.

First, God doesn't destroy his old creation; he preserves it and protects it from those who corrupt it. There are passages in the Old Testament that link God's punishment of Israel to their abuse of the land – polluting it with idolatry and social injustice (Ezekiel 36:17–18) and not allowing the land to rest by giving it a 'Sabbath' (2 Chronicles 36:21). In the New Testament, Paul reveals a creation that groans, awaiting its liberation from decay (Romans 8:19–21). That liberation (*not* destruction) is triggered by *our* liberation from sin and death. God has plans for this old, tired creation: renewal, not annihilation. That is to say, our salvation is strongly linked to the redemption of the whole cosmos!

True, there are passages that talk about the sky being rolled up like a scroll (Isaiah 34:4), earthquakes (Ezekiel 38:19), stars falling (Mark 13:24–26). Does this mean that God will destroy the earth? Not exactly. These are images of the Lord approaching to judge evil with finality: the day of the Lord. The sky being rolled back (or parted, as in Isaiah 64:1) makes a path for God to come down, as the earth trembles in fear and expectation (earthquakes). The stars were often associated with demonic powers and they *will* fall, as Jesus says in Luke 10:18, 'I saw Satan fall like lightning'. Judgment is coming, but it does not mean that God destroys everything indiscriminately.[2]

In fact, there may be a parallel between the old and new creation and our old and new bodies (1 Corinthians 15:35–58). Just as God will not destroy but renew our bodies into something imperishable, so too he will renew the old creation into something glorious.[3]

Just because God preserves nature doesn't necessarily mean that he will preserve culture as well, but it is impossible to imagine a new creation that is entirely culture-free. New Jerusalem is a city, after all. We will have a wedding supper. There will be singing – hard to sing if cultural systems such as music have ceased to exist. It will be different, but it will be culture all the same.

But *how* different will it be? How much continuity will there be between it and culture as we know it now?

Again, we cannot be certain, but there are interesting clues in Revelation 21 (adapting Isaiah 60). Pagan kings are pictured as bringing their treasures into the new Jerusalem to adorn the holy city and nourish its citizens. As Richard Mouw points out, kings were considered the representatives and patrons of their whole cultures, not only political figures.[4] The 'kings marching in' with their treasures likely points to a continuing existence for even non-Christian cultural works in the new creation.

Will these cultural works be different? Cleansed of sin? Or will we be so different (cleansed of sinful desires) that such cultural works will no longer pose a temptation? Hard to know for certain. What we do know is that culture as it exists now is a messy mixture of blessing and curse, grace and idolatry, truth and deception. The blessing continues – the curse, probably not.

The long and short of it: we have fascinating clues that not only will the old creation continue, glorified, into the new creation but so too will culture.

Culture is worth engaging *now* because it (very likely) will have a part to play *then*. Our cultural efforts in the present should serve as a preview of coming attractions, resonating with the truth and beauty of the world to come.

Jesus calls us to cultural engagement. He calls us not only to be 'in' the world but also calls us further *into* it

This kind of cultural engagement makes perfect sense in terms of Christian discipleship. Our walk with the Lord is never simply private, never simply 'me and Jesus'. We are called to 'love your neighbour as yourself' (Leviticus 19:18; Luke 10:27) and that can take a million different forms. Christian discipleship is unbreakably bound to working for the common good, making the world a better place for all of us. Loving our neighbours as ourselves *must* mean concrete cultural action – fighting for justice, living out compassion,

helping the helpless, creating beauty, revealing truth – or it is meaningless.

Jesus himself said that engagement with the world is a must for his disciples. John 17:14–18 provides a favourite catchphrase for evangelical Christians: 'In, but not of, the world.' But it is frequently misunderstood. Yes, we are to not be 'of the world'. We are to have different loyalties, different motivations for what we do (even when we pursue a common cause with some non-Christians). We are to have a different 'first love' (see Revelation 2:4–5).

But we are not simply called to be 'in the world', as though we must endure this world as best we can without getting too mired in it, until we go to heaven. No, rather, Jesus prays to his Father, 'As you sent me into the world, so I have sent them into the world' (v. 18). Why? Because 'God so loved *the world*, that he gave his only Son, that whoever believes in him should not perish but have eternal life' (John 3:16).

Jesus was a man on a mission and he expects his people to be marked with that same missional, ambassadorial identity as we go into a world that resists God's rule. We are, according to Paul, 'ambassadors for Christ' (2 Corinthians 5:20). Like ambassadors, our loyalties lie primarily not with the land to which we are sent (the world), but to our true homeland (the new creation). But also like ambassadors, we are *definitely* called to involve ourselves lovingly with the culture of the land where we now live.

Jesus calls us into the world as he was called into the world – and we must follow him. That means engaging 'the world', the culture that we share with our neighbours.

Cultural engagement isn't a threat to our souls

You might read all the above and *still* be hesitant about cultural engagement. Perhaps you still doubt that God wants us to engage culture, since the world is full of sin. Perhaps you worry that the gospel will lose its distinctive beauty and goodness, dragged down

by the very culture this book says we are to engage. Perhaps you worry that engaging with the world around will inevitably lead to worldliness.

Is this right? Should concern for personal holiness mean we should avoid participating in the culture we share with our non-Christian friends and neighbours? We cannot pretend that this isn't a real concern. We should not play fast and loose with our holiness before a holy God. Cultural works can shape imaginations *away* from God in powerful ways. Caution and discernment are needed.

Nevertheless, Jesus' call on our lives remains – we are 'sent ones', called *into* the world (John 17:18). Jesus did not provide a kind of carve-out for those who would rather not because they fear contamination from the world. The world is our mission field and we dare not draw back in order to protect ourselves and our own from worldliness. That's not how Christian discipleship works.

On what do we depend for our holiness? Where do we place our trust?

Trusting in our own ability to abstain and maintain a safe distance from the world around us is a misplaced trust. That was the confidence the Pharisees had, the so-called holy men of Jesus' day. But Jesus called them out time and time again for their sham holiness, their lack of love, the way they completely missed what the point of following God is (see Matthew 23, for example). Our Lord wants nothing to do with that sort of 'holiness'.

Shouldn't we desire instead the kind of holiness that Jesus displayed in his life? His was a holiness that expressed itself in a fierce love that drove him *into* the world. His holiness drove him to hang out with all the wrong people: tax collectors (see Luke 5:27–31; greedy, traitorous scum!) and a woman with a bad reputation (see John 4; no self-respecting rabbi would talk to her! Shocking!). Yet he never feared their influence over him – his heart remained true, fixed on his Father's will.

In fact, the influence ran quite the other way. By entering their space – eating, drinking, discussing with them – they became better, more attuned to the ways of God. Jesus' holiness was contagious, a viral purity flowing from him to others. And he promised the same for his followers – that 'living water' (the Spirit) would well up in us and overflow (John 7:37–39). We may not be able to heal lepers with a touch the way he did, but we believe that a similar healing power is on offer here to Christians moving out into the world. Engaging the world does not endanger our holiness; rather, it works it out in love.

In God's economy, 'holiness' and 'sentness' are two sides of the same coin: we exercise our holiness by loving those in the world around us. In fact, the whole idea of holiness, sanctification, rests on the idea of mission.

To 'be sanctified' means to be set apart for a special purpose – namely, to love those around us, to be present in the world as a healing force, building bridges to reconcile people to God (2 Corinthians 5:18–20).

This happens, of course, through evangelism. But we can help heal the wounds of the world in so many other ways as well.

It is with an eye to his people as a healing force sent out into the world that Jesus pleads with the Father to 'Sanctify them in the truth; your word is truth' (John 17:17). Jesus placed his trust for *our* holiness, our 'set-apartness', not in our distance from the things and people of this world. Rather, he placed his trust in God's word as truth, the truth that sets us free (John 8:32). It is likely that in John's Gospel, 'word' means both the truths that Jesus spoke *and* Jesus himself, for Jesus is 'the Word' (John 1:1). What ensures our holiness, our set-apartness to be sent into the world, is the teachings, person and saving work of Jesus.

Being holy, set apart, is not a matter of keeping a safe distance from the cultural world around us. If it were, why weren't the Pharisees deemed holy by Jesus? Why are some of the most cloistered,

separatist communities also some of the most toxic, places where abuses of all sorts take root and fester?

Rather, Jesus taught us in Mark 7 that holiness (and unholiness) comes from within. It's not what's outside that pollutes a person – the real pollution comes from within, spilling over like an artesian well into thoughts, words and deeds (Mark 7:20–23). It is as the Word addresses our hearts with the gospel and changes our desires into something that looks and feels more like the heart of Jesus that real holiness starts to grow. And that holiness takes us out into the world, not away from it.

Practical tips for grounded cultural engagement

Still, the heart is a fickle creature, easily tempted and swayed from the path of holiness. It may be that Jesus' heart was firm of purpose even as he engaged the world around him. Our hearts are far less so. How do we keep ourselves and those we love from going off the rails?

Here are a few practical tips for remaining grounded *and* engaged.

Remember, stumbling isn't the same as dying. God's grace is enough for our mistakes

In our attempts at cultural engagement, we will end up making mistakes, succumbing to temptation, falling down. While we don't want to make light of sin, *none of this is fatal for those in Christ*. In fact, treating it as if it *were* fatal can drive believers to despair and alienate them from the grace available to them in Christ.

The salvation Jesus won for us through his death and resurrection is terrifically robust. He didn't die for past sins and now we need sinless perfection or we're out. No, his blood covers our current struggles and missteps, now and in the future. So take heart, dust yourself off, rise, repent and keep following Jesus. That is to say, as Christian cultural engagement is undertaken by children of God, it

happens in the context of the faithful love and grace of God for us. That ought to encourage a bit of fearlessness (though not foolish recklessness) in our attempts to engage our world for his glory.[5]

Familiarize yourself with your private idol parade

Leaning into God's grace does *not* mean that we should be careless about what tempts us or where we are likely to stumble. Know your own heart and sin patterns to take care with *how* you engage culture. If there are areas where you are weak, go elsewhere. Part of walking in faith and repentance in the world is developing wisdom about your own limits and a desire to please the Lord above yourself.

Beware one-size-fits-all attitudes

Recognizing your idols does not mean that they will be the same as those of others in your church. It's tempting to generalize from your own weaknesses and say, 'No Christian should *ever* do x, y and z', but it is unbiblical. Paul tells Christians not to pass judgment on one another (Romans 14:13). We're not to put a 'stumbling block' in front of those with tender consciences, exposing them to temptations that they cannot bear. But neither should the 'weak' go out of their way to impose their personal rules on others in the church. We have been called to engage in various ways. Let us not interfere with those who are engaging in ways that look odd (or even disturbing) to us.

Stay connected to your local church

Finally, just because you have freedom in Christ to engage in ways that others in church might disagree with does not mean that you have the freedom to jettison the church. You *need* the church, with its ministry of word, sacrament and fellowship. No Christian is an island (to riff on Donne). No Christian is so healthy that there is no need for brothers and sisters to offer reality checks. No Christian is so wise that he or she can't do with exposure to God's word preached on (at least) a weekly basis.

Furthermore, we've got to be willing to do church in a way that will feel intrusive (though not abusive). You must be willing to let a trusted brother or sister into the nitty-gritty, not-so-pretty details, dynamics and motivations that you hide from view. Someone needs to be praying for you, able to call you out, able to weep or rejoice with you. You've got to let someone get close, close as family. Closer, maybe.

At the Turnau house, we love anime – Japanese animated movies and television series. A cardinal principle that guides our favourite series (*One Piece*) is *nakama*. It's a Japanese term that's hard to translate, but means something like colleague, friend, ally. For the characters in *One Piece*, it means 'true family' – those you have worked, played and fought alongside. They know you inside and out. They would willingly lay down their lives for you, and you for them. You may have differences and arguments but, underneath it all, you love them as yourself. Church. Is. *Nakama*. Find trusted *nakama* with whom you can be transparent. We have seen apparent believers drift away because they have disengaged from relationships in the church. We've also seen believers who have been through hell persist and grow in their trust in the Lord *because* they've kept those connections, stayed accountable and had prayer support the whole way.

Brothers and sisters in Christ can keep you sane as you seek to engage a sometimes insane world.

Conclusion: engagement as discipleship

Engaging culture is a vital part of being a disciple of Jesus. The arguments for it are strong. It's a God-given call. Our cultural efforts will (likely) endure. Though we have a different loyalty from those of the world, we are called into the world. We have been set apart to engage the world around us. It need not stain us if we allow our hearts to be renewed by the word and keep connected to the church.

22

If you agree with us, then the obvious next question is, but how? How would God have us engage this world as his ambassadors? That question will occupy us for the next two chapters.

Discussion questions

1 What does it mean to 'engage culture'? It's a phrase that's thrown around a *lot* by well-meaning Christians. Can you give a precise, practical definition?

2 Why is culture worth engaging? Why is it more than simply a stumbling block for our souls? What possible good could come of it?

3 What did Jesus really mean when he called his disciples not to be *of* the world, but to go *into* it?

4 How did Jesus define what we would call 'sanctification', honouring God in our walk with him? Is it different from simply distancing ourselves from 'the world'?

5 Talk through the points offered under the heading 'Practical tips for grounded cultural engagement'. Are there any you disagree with? Would you add any?

Getting started

- What can you do today, this week, this month to engage culture as we are called to do? How can we learn our culture well to be good ambassadors of Christ?

- Identify an area of culture that you enjoy engaging – maybe watching films, reading novels, going to gigs or other events. What opportunities do you have to begin or to deepen conversations about your chosen area of culture? Could you invite friends along and start a book group or film night and join an online discussion group?

- Talk to your pastor or another church leader about cultural engagement – ask how they might be able to support you in engaging culture, both with encouragement and accountability?

Notes

1 Gordon D. Fee, 'Concluding exhortations', *Philippians*, IVP New Testament Commentary Series (Downers Grove, IL: InterVarsity Press, 1999).

2 One of the most troubling passages, which some have taken to mean that God destroys the earth in fire, is 2 Peter 3:10–13, but we will not address it here. For an extended discussion of that passage, see Ted Turnau, *Oasis of Imagination: Engaging our world through a better creativity* (IVP, 2023), pp. 22–24.

3 Richard Middleton, *A New Heaven and a New Earth: Reclaiming biblical eschatology* (Grand Rapids, MI: Baker Academic, 2014), pp. 201–204.

4 Mike Cosper, *The Stories We Tell: How TV and movies long for and echo the truth* (Wheaton, IL: Crossway, Kindle edn, 2014), loc. 675–681.

5 See Cosper, *The Stories We Tell*, loc. 675–681.

2

How *not* to engage culture: culture warring

Jesus calls us to love and serve our neighbours. Stop
undermining this calling by fighting culture wars to impose
'Christian values'.

Culture warring is a less-than-biblical, less-than-Christlike approach.
It *undermines* our Christian cultural witness.

Rather than simply present this argument 'straight up', we thought
that it would be interesting and entertaining to present it as dialogues
from an imaginary documentary (part 2 of the documentary appears
in the next chapter).

Understanding that we live in a post-Christian world

Before we proceed to the dialogues, though, we ought to be clear about the difficulties of engaging a post-Christian culture. 'Post-Christian' is a phrase that rubs some the wrong way. We Christians in the West would like to think of our countries as rooted in a Christian heritage, and so they were to a greater or lesser extent. But they have moved away from those roots in quite spectacular ways in the past three or four decades. People have grown up in a context where it's commonplace to attack, marginalize, dismiss and simply ignore a Christian perspective. Of course, it's not the same everywhere. Some areas of your country are going to have stronger vestiges of the Christian past than others. But, even in the more strongly Christian areas, the media and entertainment pour in through our phones, televisions, radios and the Internet, bringing the influence of a world that's grown tired of the gospel to right under our noses.

Statistics reveal that it is not likely to get better any time soon. The US-based Pew Research Center shows a decline in the percentages of those who call themselves Christian from 78 per cent in 2007 to 65 per cent in 2019. During the same period, the percentages of the religiously unaffiliated (the religious 'nones') increased from 16 per cent to 26 per cent.[1] Later research by the Public Religion Research Institute has shown that in more recent years Christian decline has slowed, as has the growth of the nones.[2] Still, 'religiously unaffiliated Americans constitute a larger share of the American public than the three most prominent religious groups in the U.S.' (that is, white 'mainline' Protestants,[3] white evangelicals and white Catholics).[4] The USA has arguably entered a 'post-Christian' phase of its history. This is uncharted territory.

For the UK, the picture is even more concerning. According to a YouGov poll conducted in 2020, 55 per cent of British people do not

subscribe to any religion, versus 34 per cent who say that they are Christian.[5] Even more surprising, only a quarter of British people believe in a god – and only 56 per cent of Christians believe in God![6] So the UK, too, is post-Christian.[7]

This trend is seen throughout the English-speaking world as the centre of gravity of the Christian faith shifts from the Global North and West to the Global South and East.[8] The Christian world we grew up in is evaporating. Christians now must make their way as a minority culture within a larger secular, relativistic mainstream full of alternative beliefs . . . and increasingly suspicious of Christian beliefs. *That* is the context for our cultural engagement.

Christians in the UK and the USA typically have defaulted to two different strategies: culture warring (using politics to try to force cultural change) and withdrawal (erect walls to keep us and ours safe from the outside world). We would like to argue that neither really makes sense in our current situation and both fall short of what the Bible calls us to. But instead of making you, dear reader, slog through straight prose, we thought we would change it up a bit by offering a script from an imaginary documentary in which we interview and debate with a fictional representative of each position (hopefully without trivializing or being dismissive). Here is the first. The second is in chapter 3.

Dialogue 1: The Knight

The scene takes place in a richly furnished office – ornate Persian rug, big mahogany desk, forest-green leather desk chair, the wall adorned with family portraits, plus a few of significant politicians, one of a politically conservative president.

Sitting behind the desk, fully in command, is the KNIGHT, *a man in his mid-fifties, hair greying at the temples, keen blue eyes, clean-shaven, dark suit, dark-red power tie. He speaks with the broad, flat accent of the Midwest in the USA. He eyes* TED *and* RUTH *from across the desk, waiting for the cameras and lights to finish being set up.*

TED: OK, we're rolling.

RUTH: So, Mr Knight, what motivates you? What gets you out of bed in the morning? Tell us your story.

KNIGHT: I was a pretty wild kid in college. A friend invited me to a meeting of a parachurch organization. A while later, I gave my life to Jesus. It wasn't too long after that I became politically active, started volunteering, got my law degree and started working for conservative causes.

TED: Why was that – you getting politically active, I mean?

KNIGHT: My church played a big part in that, showing me how great this country was, how terrible it has become, what a mess awaits us if we don't fix it. We've got to get this country back on track, back to what it was before everything started going downhill.

TED: Like it was in, say, the 1950s?

KNIGHT: Yes, when the whole community held traditional Christian values in common.

RUTH: Like with Jim Crow laws?[9] Lynchings? Those kinds of values?

KNIGHT: *[a bit ruffled]* No, of course not those things. They were horrible. Unjustifiable. I mean things like intact marriages, less sexual confusion, no abortion. It was a different world.

TED: But you do get Ruth's point, right? We can look at the past with awfully selective vision. Truth is, there is no 'golden age' when everything was good and holy. Every age is populated with sinners and so every age is in need of reform.

KNIGHT: But surely you can see that this age is *especially* far from biblical standards. People can't tell which gender they are, for heaven's sake.

RUTH: And sexual confusion is worse than hating, oppressing and killing people made in God's image because of their skin colour?

KNIGHT: I did *not* say that, nor even imply it.

TED: No, you didn't, but Ruth is pointing to a real danger. Nostalgia's a trap. We shouldn't be glamorizing a lost past. As the Teacher

said in Ecclesiastes 7:10, 'Say not, "Why were the former days better than these?" For it is not from wisdom that you ask this.'

KNIGHT: The Bible *also* says, 'Thus says the LORD: "Stand by the roads, and look, and ask for the ancient paths, where the good way is; and walk in it, and find rest for your souls. But they said, 'We will not walk in it'"' (Jeremiah 6:16). That's what our culture is now doing – refusing the old ways in the name of a false 'progressiveness'.

So, what's wrong with appreciating the virtues and beauty of bygone times?

TED: In general, nothing. I miss my home town, what it was. But I also know that I can never go back there again, not really. Heck, they even built an addition to the house I grew up in. It's completely different. My home, my home town – it's alive only in my mind.

But an overly fond version of the past can be a trap if you want to engage culture in the present.

KNIGHT: Why? What's wrong with holding on to the best of the past, wanting our culture to return to those days?

RUTH: Because you become so dazzled by that vision of the past, of what you miss, what you have lost, that it can blind you to the ugliness of the past, as well as to hopeful signs in the present. Nostalgia tends to be a very selective kind of vision – it can even mythologize the past, dreaming of a time that never really was. And it can make you overlook some of the ways we can reproduce the ugliness of the past while we're trying to recapture it.

KNIGHT: I only want this country to reflect biblical values. That's all. I want this country to be the best it can be – and I believe that benefits not only Christians but also society as a whole.

TED: And that is admirable. But to truly do that, you need to let go of the past-as-superior. You need to be open about some not-so-comfortable truths about a cherished past. You cannot make a country great by erasing its past, because so often the past bleeds into the present.

KNIGHT: I know that it's not always lived up to its ideals, but we can do so much better. After all, our country has always been a Christian one. I cherish that past – what we were and what we can yet become. *[Rises]* You two want coffee? I need coffee.

[Exits office, out into a marble-floored hallway. Walks towards the lifts at the end of the hall.]

RUTH: About that . . . the 'cherishing the past' part. I mean, there have been strands of American culture that stem from the Puritans (not that they lived up to Christian ideas, especially regarding slavery). But America has always been more than just a home for Christians, right? The two Thomases – Paine and Jefferson – they wouldn't be warming a pew on Sundays, now, would they?

KNIGHT: They are exceptions that prove the rule – there's no doubt our past is predominantly Christian.

TED: I'm not so sure. Enlightenment Deism has always been part of this country, as has atheism. For example, even in the Victorian era, there were figures such as Matthew Arnold lamenting the withdrawing of the 'tide of faith' in his poem 'Dover Beach'. The majority were still Christian, but even in 1851, that was beginning to change. And as the country has grown, we have welcomed in more and more people from all over the globe. That makes us more diverse, more of the melting pot we like to call ourselves. We are now a diverse nation.

[They reach the lift, the doors of which are just closing.]

KNIGHT: Hold that, please! *[Puts a well-aimed foot between the closing lift doors. The three enter together, accompanied by a couple of extras. The lift goes down from the thirty-second floor towards the lobby]* So what do you suggest? That we simply abandon our

Christian principles and let any competing morality – progressivism, relativism, Islam – to take its place?

TED: I'm saying that, in a democracy, we've got to find compromises that protect all human rights. I don't agree with progressive sexual values either, but I also don't want to see gay people beaten up or scapegoated. I don't think that's what Jesus calls us to.

KNIGHT: What do you mean? Doesn't Jesus want a society that follows his righteousness?

TED: Surely. It's the *how* that worries me. Jesus wants a righteousness that flows from the *heart* out into actions, not one that is coerced. If you want true faith and obedience, you cannot make them mandatory with an 'or face the legal consequences' situation. That kind of freedom will always hold the potential for moral mess.

KNIGHT: Moral mess? Christian people fear for the safety of their children! We've got to be able to enact laws to keep them safe from this corrosive influence, laws that reflect our Christian heritage and God's laws written in nature and in the Bible.

RUTH: I'm a mother and I want my children protected. But we can do that without making those who choose a different life-path feel like pariahs. People need the freedom to make their own minds up about whether God is real and what it is he expects of us. Don't you see how much hurt and resentment you cause in the gay and trans community when you start passing laws that target them and exclude them in the name of protecting *your* rights?

KNIGHT: I'm sorry if we hurt their feelings, but we have a higher priority. We need to keep our kids safe! *[The others in the lift start to look a bit nervous – the conversation might become heated]*

RUTH: *[in a quiet, restrained voice]* I don't think fear is the best motivation for Christians. My father was a pastor who worked with urban gangs and I took care of people dying from AIDS when the church communities had turned their backs on them *because they were afraid.* I don't think Jesus calls us to a life of defensiveness and fear.

31

KNIGHT: I am called as a father and a husband and a citizen to participate, to get people elected who will do what must be done.

TED: So that's your answer? Pass laws that force those who don't agree to . . . behave as you want them to?

KNIGHT: That's what laws are for. To the potential murderer, the law says, 'Don't do it!' To the thief it says, 'You'll do time for that!' We must have a sane, Christian social order.

TED: No matter the cost? *[The lift arrives at the lobby. The doors open]*

KNIGHT: After you. *[The three exit into the richly adorned office building lobby and cross to a café]* What do you mean, 'no matter the cost'? *What* cost?

RUTH: No matter what populist leaders you have to get behind to pass those laws? No matter what elections you have to tamper with? No matter what lies have to be told?

[The three sit round a small wooden table with wire-backed chairs.]

KNIGHT: What are you accusing me of? I'm not in favour of any of that.

TED: And yet you campaign for and help to elect leaders who are, to put it gently, morally compromised and not exactly on good terms with objective truth.

KNIGHT: We vote for people who deliver on important issues, such as abortion. We cannot let people keep killing innocent babies in the name of sexual freedom.

TED: I agree with you, I do. We agree with you that Christian leaders need to speak prophetically, and winsomely, on this issue. But there are other issues: racial justice, helping the poor, reining in businesses that cheat and abuse workers – all issues that conservatives tend to ignore. Christians need to be able to challenge both sides, even if it makes us politically homeless . . . for now.

And we definitely should not take up with scoundrels, no matter what they 'deliver'. Putting our energy and enthusiasm

behind morally compromised political leaders undermines our own integrity.

KNIGHT: Show me a leader who's spotless . . .

RUTH: *[shakes head – not going to let that pass]* We're not talking about a few spots here and there. We are talking about people devoid of any sort of Christian justice or mercy, who are cynical and only in it for themselves. You cannot back that kind of person without undermining your own Christian integrity. It's always been a problem with the culture wars but, lately, they haven't even been subtle – they've stripped away the window-dressing.

WAITRESS: What can I get you folks this afternoon?

KNIGHT: Cappuccino.

RUTH: A cup of rooibos, please.

TED: You have any Ethiopian Sidamo pour-over?

[Beat. All three look at TED. WAITRESS rolls eyes.]

TED: *[trying to seem unruffled]* What? I'm into coffee.

WAITRESS: I'll have to see

TED: *[resigned]* Whatever you have brewed. With milk, please.

RUTH: So . . . where were we? Oh, yeah, the integrity, and *lack* of integrity, of the leaders we choose to represent us.

KNIGHT: Well, to be fair, the movement has been trying to recruit better people. There are better people waiting in the wings.

TED: But we're missing the bigger picture. Are these laws so important that we're willing to sell out our Christian witness for them? What is it we're truly fighting for? If it's just self-protection and our own freedoms, then how are we any better than every other secular lobbying group out there?

KNIGHT: Because God *is* on our side.

RUTH: Is he, though? Or do we simply assume him to be? In the Book of Joshua, chapter five, when this man came to Joshua with a drawn sword and Joshua asked if he was for them or for their

enemies, what did this commander answer? 'Neither. I have come as the Commander of the Lord's army.' And Joshua fell face down and took off his shoes, for he was on holy ground. Seems to me we can *never* assume that God's on our side. It's quite the other way round – we'd best be sure we're on *his* side!

KNIGHT: *[drily]* Very dramatic, but we are fighting for *Christian* causes, causes that are ultimately good for everyone: protecting the unborn, protecting our children in schools, protecting the sanctity of marriage.

TED: All good things, to be sure. But I *don't* see this movement fighting for other things that are equally important to God and the common good: justice for the poor, the widow, orphan and migrant. I don't see them speak up on behalf of the vulnerable. I don't see them standing up to abuses of authority by the police and courts. Not unless it affects them directly. Christians are *still* coming off as a special-interest group that couldn't give a flip for the common good!

Strategically, that's disastrous. Instead of doing the hard work of trying to persuade those who believe different things from us, we just try to dodge those difficult conversations with the opposition and instead force them into submission. And that will only lead to resentment and cultural backlash.

KNIGHT: Some things are worth that risk. Look at the victory we won in the Supreme Court recently. Unborn lives will be saved.

RUTH: For now. Look, I'm not sure that victory will last long. I've never seen so many mobilized by sheer anger. If we're trying to win people for the gospel, this doesn't seem to be the way to go. There is a *lot* of animosity towards Christians right now. The Christian church leaves a bad taste in people's mouths. We have become obstacles to the gospel.

TED: And all of this comes from trying to force our point of view without even trying to convince the culture-makers – the screen-writers, authors, journalists, musicians. They're the ones who sway people's hearts over time.

[A pair of smartly dressed men pass with closely trimmed beards, one with a tattoo sleeve of Celtic design. KNIGHT eyes them briefly.]

KNIGHT: Those Hollywood liberals will never listen to us. It's a waste of time! Better to let the law do the talking – laws can shape culture, as well as culture shaping laws.

TED: But that simply invites a backlash the other way. They see that we're just about political power and they'll wrest it from us one way or another. We are the *minority* here, remember, and will remain so unless there's a third Great Awakening.[10] And when that backlash comes, expect Christian schools and colleges and churches to feel the sting. And why? Because we Christians have chosen not to seek peace, but to play politics.

KNIGHT: Maybe, but we'll take what we can get while we can get it.

RUTH: There's a long history of politics just being about power – who has it, how to keep it. That's not going to change any time soon. And Christians have played along with that game. But there's a better way, one in which we allow ourselves to relinquish power for the greater good. Why can't we change the way we do politics so that we make a name for ourselves that speaks of a concern for others, works for the common good, for love and peace and justice?

KNIGHT: Look, ending abortion and upholding a biblical view of marriage *are* 'working for the common good' because they uphold a biblical definition of love and peace and justice. But those who promote 'progressive' values will push back. A culture war is inevitable when people oppose biblical principles. It can't be helped.

TED: Those issues might be *part* of the picture, but you distort our Christian witness when you focus *solely* on winning those particular battles at all costs. Culture war isn't inevitable if we really engage well through persuasion and telling a better story. We lack the imagination to try to sway hearts through art and entertainment.

KNIGHT: Seriously? *That's* what you're going with? Arts and entertainment?

TED: You'd be surprised how much of an impact on shaping imaginations that stuff has. And the church has ignored it – or made awkward attempts at engaging it, which is kind of worse. Instead, it's tried to force its will and the result has been nothing but ill will.

RUTH: But, even more troubling, we've forgotten what Jesus has called us to.

KNIGHT: Really? I thought we were fighting for his cause.

RUTH: That's just it – he didn't call us to fight . . . at least, not in *that* way. He called us to *love* God and our neighbour, even lay down our lives for them. It looks like we don't do that very well.

KNIGHT: Loving others sounds nice, but culture-wide, it won't change anything. The country will simply continue to go down the drain. We'll lose the culture. We need something that will compel larger-scale cultural change. *That's* why we engage in the culture wars.

TED: But without love, will any change wrought by the culture wars be worth it? Or will it simply set up a legalistic regime that forces conformity (if we succeed), fanning the flames of resentment in our children and inviting a backlash that will leave things worse than they are now?

KNIGHT: Wait a minute – what we do *is* loving, in that it's good for the country. The culture wars are wars for the country we love.

TED: Not if it's done in a manner that is not loving, but in a way that compromises the integrity of our witness by following scoundrels and hating those we're called to love. For Christians, ends absolutely do *not* justify means.

KNIGHT: Well, we'll have to agree to disagree. *[Pauses a beat]* Do you have a better idea? *[Gesturing to the* WAITRESS*]* Bill please, Susan.

RUTH: We do and Ted's already hinted at it (we like foreshadowing). But you'll have to wait until the next chapter.

TED: *[turns to camera]* Let's sum up what we've covered here . . .

[Title onscreen: 'The nostalgia trap'.]

RUTH: First, we think that nostalgia – seeking a lost Christian consensus in past decades - is a losing proposition. We end up blinding ourselves to the unpleasant truths of what the past was really like. And that can also blind us to important distortions that continue into the present. Nostalgia can be a potent trap.

[Title onscreen: 'A Christian nation?']

TED: Second, while we appreciate the Knight's heart-motivation for this culture to better reflect Christian values, we questioned his assertion that ours is a 'Christian nation'. It certainly isn't monolithically Christian now and it wasn't even in its past. Since its founding, it has been a mixture of Christian, deist and atheist threads, though the Christian influence has been profound. As the country matured as a democracy, it has added more influences into itself. We cannot simply erase those and remain a democracy.[11]

[Title onscreen: 'The fear factor']

RUTH: Third, we noted how so much of this approach is motivated by fear and self-protection. We want to protect ourselves and our children, and laws need to be part of ordering society. But should self-protection be our primary motivation? Is defending territory the way to go about engaging culture? It only provokes resentment from those who disagree with us and leaves us looking more like a self-interest lobbying group rather than people who are working for the common good.

[Title onscreen: 'Compromising with scoundrels']

TED: Fourth, this fear and need to defend territory (the 'Christian nation') helps us to overlook the general lack of moral integrity of some leaders. We just don't care, as long as he's on our side. But what kind of Christian witness to the rest of the culture does that provide? We compromise *our* integrity when we wink at sins (and perhaps crimes) committed by our leaders.

[Title onscreen: 'Being a minority that acts like the majority']

RUTH: Fifth, from a strategic standpoint, trying to force our cultural values on others by leveraging political power is doomed. When we ignore the culture-makers, the storytellers of our culture (the artists and entertainment creators), we end up paying for it in the long run. There may be short-term victories, but there will be a cultural backlash. That's what we see in the declining church attendance, as our children walk away from the faith.

[Title onscreen: 'Pushing through an agenda is not love']

TED: Finally, we questioned whether the Knight's politically aggressive approach really fulfils the law of love that Jesus calls us to. Even if we consider our goal to be that of good for the whole culture, the ends never justify the means. We cannot call it love if we speak and act in hateful ways towards those we disagree with.

RUTH: That wraps up this segment. Join us for our second documentary with . . . the Gardener.

TED: Cut! That's a wrap.

KNIGHT: What? No strings swelling in the background music.

TED: We'll do that in post. *[Music swells majestically].*

Discussion questions

1 What does it mean that significant parts of the Western world are 'post-Christian'? What does it mean in terms of cultural influence?
2 What is the problem with nostalgia as the basis for cultural engagement?
3 Is either the UK or the USA a 'Christian nation'? Discuss some of the issues and problems with Christian nationalism. (Feel free to consult other works, such as Paul D. Miller's *The Religion of American Greatness*, mentioned in note 11, earlier this chapter, and the Further reading section).
4 To what extent do you see Christians around you responding to the surrounding culture with fear? What's wrong with that, biblically?
5 Is God on our side? What practical, attitudinal and lifestyle changes do we need to make to ensure that *we* are on *God's* side?
6 Where has the church (perhaps your local church) fallen short in championing leaders who are likely not worth championing? (Skip this one if you feel that the discussion may descend into a shouting match. That in itself may be worth discussing . . .).
7 What causes 'cultural backlashes'? In other words, what does a culture-warring approach overlook?

Getting started

• What are some practical steps your church could explore that, rather than indulge in self-protection, would serve the common good? What difference would that make to how the church is perceived in your local community?
• Think through the implications of loving your enemy for cultural engagement. What would your church's missions agenda (foreign and local) look like if you collectively loved your enemies? What would change in your church's outreach

strategies? What underserved, difficult and perhaps taboo areas of your community would you prioritize? How could you get involved, to show love for enemies through cultural engagement?

Notes

1 Pew Research Center, 'In US, decline of Christianity continues at a rapid pace: An update on America's changing religious landscape', Pew Research Center (17 October 2019), <www.pewresearch.org/religion/2019/10/17/in-u-s-decline-of-christianity-continues-at-rapid-pace>, accessed March 2023.

2 Ryan Foley, 'Rise of the "nones," decline of "white Christian America" slows in US, new survey shows', *Christian Post* (12 July 2021), <www.christianpost.com/news/rise-of-the-nones-slowing-in-the-us-new-data-shows.html>, accessed March 2023.

3 'Mainline' denominations are the older Protestant denominations in the USA. They tend to be more theologically liberal than evangelical denominations.

4 Foley, 'Rise of the "nones"'.

5 Milan Dinic, 'How religious are British people?', YouGov (29 December 2020), <https://yougov.co.uk/topics/society/articles-reports/2020/12/29/how-religious-are-british-people>, accessed March 2023.

6 Dinic, 'How religious are British people?'

7 See also Linda Woodhead, 'The rise of "no religion" in Britain: The emergence of a new cultural majority', *Journal of the British Academy*, vol. 4 (December 2016), pp. 245–261, <www.thebritishacademy.ac.uk/documents/1043/11_Woodhead_1825.pdf>, accessed March 2023.

8 Gina A. Zurlo, Todd M. Johnson and Peter F. Crossing, 'World Christianity and mission 2020: Ongoing shift to the Global South, *International Bulletin of Mission Research*, vol. 44, no. 1 (January 2020), pp. 8–19, <https://journals.sagepub.com/doi/full/10.1177/2396939319880074>, accessed March 2023.

9 Jim Crow laws were a system of local laws that were established, beginning in 1865, immediately after the US Constitution's 13th Amendment outlawing slavery. They were intended to solidify segregation and ensure that black people could not gain financial independence or seek redress for crimes against them. In effect, these laws continued the subjugation of black people that they had endured under slavery in a country that had outlawed slavery.

10 The Great Awakening was a massive spiritual renewal in the USA. It happened in the UK, too, but is known as the Evangelical Awakening or Evangelical Revival.

11 Here we are touching on an ideology called 'Christian nationalism' that has spread to certain corners of the church in both the USA and the UK. It would take too much space to do a deep dive into it here, but for those wanting to explore further, we recommend an excellent book by Paul D. Miller, *The Religion of American Greatness: What's wrong with Christian nationalism* (Downers Grove, IL: IVP Academic, 2022). Miller focuses on American Christian nationalism, but the principles apply to any national context. We found his distinction between patriotism (a proper love of country) and nationalism (an altogether more exclusivist vision of nation) extremely helpful (it is the subject of the book's second chapter).

3

How *not* to engage culture: Christian bubbles

Jesus calls us to seek the good of our communities,
so we must build bridges rather than retreat into
'safe' Christian bubbles.

Should Christians focus on building and preserving a distinctively Christian counterculture? Do we need to step back from wider culture to avoid compromising our faith and being 'infected' with worldly values?

We pursue these questions as we continue our imaginary documentary with an interview with the Gardener – that is, one who advocates for a Christian faith that *withdraws* from culture into its

own private walled garden. (If it helps our younger readers, you may reimagine the setting as a podcast).

Dialogue 2: The Gardener

Our scene takes place in a well-kept garden (roses, hydrangeas, gravel paths across neat lawns) surrounded by ivy-covered stone walls. The camera tilts upwards from the flower bed to the sky above the wall: it is sunny, but menacing dark clouds gather on the horizon. It tilts down to find the GARDENER *digging over an area to plant some seeds. She is a bespectacled woman with a kindly face, though stern – she will not put up with any nonsense. She is perhaps in her early sixties, physically fit for her age (she gardens), wearing a brightly coloured garden apron and fashionable but sensible clothes beneath (nothing too fancy). She speaks in a gentle Welsh accent.* TED *and* RUTH *enter the scene.*

TED: *[cheerily]* Lovely group of catechumens you have growing there.

GARDENER: *[not looking up]* They are dahlias.

TED: *[singing to the tune of 'Hello Dolly']* Hell-o, dahlias! Well, hell-o, dahlias![1]

GARDENER: *[irritated, but still not looking up]* May I help you with something?

RUTH: We just had a chat with Mr Knight. Do you know him?

GARDENER: Yes, lovely fellow. A bit aggressive. Thinks he can save the world that way . . .

RUTH: And you disagree? Is that why you're in here?

GARDENER: *[looking up for the first time, fixing* RUTH *with a hard stare]* You don't understand, do you, dear? The culture wars are over – we lost! The barbarians are at the gate. Institutions are corrupting our young. We're losing the hearts and minds of our children to the progressive agendas that mainstream media push relentlessly. *[A resigned sigh, but digging using the fork more pointedly, as if to emphasize each phrase]* Time to look *inwards*, take *stock* and

preserve what we have left. Do what Saint Benedict did when Rome started rotting from the inside out: leave behind the craziness of culture and look to our own.[2]

TED: *[brows furrowed]* And what led you to that depressing conclusion?

GARDENER: *[a bit exasperated at* TED's *obtuseness]* Well, look around! It's not just a crisis in mainstream culture, no! It's a crisis *inside the church itself!* We are losing any sort of Christian sense of history, character, worship, holiness . . .

RUTH: How do you mean? *[Finds a wrought-iron bench near the* GARDENER*]*

GARDENER: Take this moralistic therapeutic deism, for instance. Makes God into a butler, to be called on at your convenience, snap of the fingers . . . as long as you're a *nice* person. Watered-down gobbledygook, that is! Nothing in common with historical, conservative Christian convictions.[3] No. Engaging culture the way you think of it is a losing proposition. The culture you're trying to engage – especially *[Eyeing* TED *with a steely glare] pop*ular culture – will only lead to compromising the faith until there's precious little left. We become the salt that's lost its savour, good for nothing but to be 'trampled underfoot' (Matthew 5:13). And with no real faith, no divine power, then the young people leave the church and, well, *[Deflates a little]* that's the end of that, isn't it?

TED: *[incredulous]* What . . . you mean . . . the end of the church?! For real? *[A bit sarcastically]* Well, Jesus *did* say, 'The gates of hell shall not prevail against it' . . . unless you have morally relativistic popular culture to contend with. In that case, *all bets are off!*'

GARDENER: *[annoyed, searches in apron for seeds]* Mock if you like, but we've never seen a cultural crisis like this in the West before. Look at the statistics – church membership is down. Bible knowledge is down. It's all going downhill. Hell in a handbasket, if you like!

RUTH: But you must realize how alarmist that sounds.

GARDENER: Well, someone must ring the alarm if you will not!

TED: So . . . what is to be done?

GARDENER: As I said – make like Benedict and *withdraw*! Form intentional communities, a thick culture that values learning its own traditions, disciplines and habits. We must retrain our imaginations, intellects and desires so that we truly pursue God and holiness. Only in this way can we endure and survive the present chaos.

RUTH: And that *definitely* means *not* engaging culture.

GARDENER: Yes, precisely. Engaging culture only invites corruption and evisceration of our own best traditions. Cultural engagement is often just an excuse to compromise our heritage in the name of being 'relevant' or culturally 'with it'. But it undermines our pursuit of God and holiness. This current post-Christian craziness – *including* popular culture – is like aphids on the roses, like too much acid in the soil. It causes our faith to wilt and fail. The average Christian will buckle under those cultural pressures. We need a strong community to provide shelter, a place where pursuing God feels natural.

RUTH: What about outreach? What about evangelism?

GARDENER: *[waves hand vaguely]* Oh, don't worry, lovely. We'll continue reaching out. But really, what is evangelism? Passing on words? Bringing someone to a decision and then letting them go? No, for heaven's sake! It's an introduction to a whole way of life and that can only be learned in church communities.

You see, it is only through telling our own story clearly and deeply that we can even *hope* to reach others. By deepening our own roots and building our own spiritual muscles through a resolute commitment to spiritual disciplines, we can reach others. They'll be attracted by our worship and lives and enter in.

TED: *[pauses, considering]* Well, I do agree that much of what's passed on as the Christian faith is pretty weak tea and hopelessly

mixed with unbiblical ingredients, such as Christian nationalism. And I agree that we need more good teaching and intentional communities, a real sense of the Christian life lived out in community. Too many churches do a poor job of teaching people the Bible in depth, the roots of their faith, as you said. They don't really teach them how to live it out day to day, how to bring up and catechize their kids. And so there's little resistance to the overall drift of the main cultural currents. You're right about that.

GARDENER: *[waiting for the 'But . . .']* But you don't think withdrawal is the answer because . . . you think popular culture's not to blame? *[Finds watering can, begins watering the seeds she's just sown]*

TED: No, no. I think popular culture often functions as a sort of combo-package secular/pagan catechesis and sentimental education that helps us to feel what life is like in a world where God is dead or irrelevant. Much of popular culture spends its time polishing idols and that *can* indeed be dangerous for those who lack discernment.

GARDENER: *[raises eyebrows]* Oh, so you agree with me, then?

RUTH: No, not entirely. I think I see where Ted is going with this. Cultural works may have idolatry, but they're *more* than just idols-on-parade. There is also much to learn from even non-Christian cultural works – what theologians call common grace, hints of God's love, justice and beauty to be found in the works of those who don't follow Jesus.

TED: Further, those elements of common grace are essential for building bridges with non-Christians. If we're serious about reaching out to non-Christian friends, we need to familiarize ourselves with the works that open up vistas for them, worlds of meaning that shape their imaginations. We need to learn to speak the language of those worlds.

GARDENER: But only at the cost of spiritual compromise, right?

TED: No, and there's where I disagree with you. I'm not convinced that Christians have to choose between pursuing God in

intentional community and engagement with the culture (especially arts and entertainment) around us. In fact, done right, engagement with culture can bring out God's glory more fully, because we learn to see the common grace in culture for what it is: God's glory shining through his gifts to us. We also learn to see our culture's idols for what *they* are: systemic distortions of God's blessings, twisted gospels. When the gospel is contrasted with the darkness and distortion of non-Christian counterfeits, it helps us to see the real thing in bright relief, like a portrait of grace in chiaroscuro.[4]

GARDENER: *[wipes dirt from hands on apron, furrows brows and moves to a different patch in the garden]* That's a pretty flimsy rationalization, mister. It sounds like a convoluted distortion of worship. You will only produce a generation mollified and transfixed by shiny false gods, their eyes drawn away from the true God.

TED: We don't think so. Thoughtfully, critically engaging culture, even non-Christian cultural works, can help you to appreciate God's glory more. That's why James says, 'Every good gift and every perfect gift is from above, coming down from the Father of lights' (1:17). In fact, you find such thoughtful, critical appreciation of non-Christian culture throughout the Bible, from the lament for Tyre in Ezekiel 27 – all that would be lost because Tyre's cultural treasures *were* treasures – to Paul's use of pagan poets in his speech in Athens in Acts 17. He's not only practising good communication skills; he's also drawing on the insights of their culture.

GARDENER: Critical? *[Starts weeding vigorously, tossing weeds over her shoulder]* Thoughtful? Who *does* that? Most Christians simply consume culture. They switch their brains off and soak it all in.

TED: No doubt, but it doesn't have to be so. *[Sits on the ground nearby]* Isaiah says in chapter 44, verse 19, 'No one stops to think' [NIV].[5] The key is to stop and think, to engage intentionally, critically,

reflectively, submitting every insight and delight to God. Such reflection is what separates idol worship from worshipping the living God. Cultural engagement is precisely a call to 'stop and think' about the culture around us. It is a practice of Christian obedience in the area of cultural consumption and creation. Done correctly, it should lead us into deeper worship.

GARDENER: Still sounds like a rationalization.

RUTH: Not rationalization; cultural apologetics and appreciating the gifts God's given us … even when they don't have a Christian label on them.

TED: I've written about how to do this with popular culture, for adults *and* kids.[6] It's been my experience that reading, watching, listening and playing in popular culture with my kids gave us a *lot* of opportunities to talk about what is true and right and good.

GARDENER: I don't buy the idea that critical reflection is enough. Aren't you and your children being spiritually formed … or, rather, *de*formed, by a type of worship that shapes desires *counter to* what God desires? Through your cultural engagement, you are actually producing a misshapen love.[7] *[Carefully picks up a worm and places it in a patch of soil away from where she is weeding]* You're better off over there, lovely.

TED: No, I concede that is a risk. That's why we need to think through what we're engaging and why. We need to know where our hearts are weak and prone to stumbling. And, positively, we need worship – the kind of rich, deep learning and living and celebrating that you are advocating.

Look, I think you're right about the fundamentals. The church needs to tell its own story and tell it well. And I agree, living out the Christian story in community – our marriages, families and friendships – can have a profound impact on non-Christian friends. But sometimes that story is told best when confronted with *alternative* stories, *in contrast* to those stories. I know that I've learnt a lot about heroism, sacrifice, love, false worship (which

highlights true worship) by watching *Dr Who* on the BBC and *Arcane* on Netflix. We need to train Christians how to do that – how to become intentional in their engagement with non-Christian culture.

RUTH: And most churches do a terrible job teaching their people how to engage culture so we can appreciate, critique, grasp the nuances of and gain insights from the works of non-Christians. If they do anything, they teach them how to hate non-Christian culture as the enemy. That only succeeds in putting up a wall between us and the people we're trying to reach.

GARDENER: *[shakes head, then rises from kneeling and moves to another patch to weed it]* It is a question of priorities. Evangelicals are so keen on being *[gestures air quotes]* 'missional' and 'relevant' that they forget our *main* mission, which needs to be our own pursuit of God, holiness and right worship.

TED: *[TED and RUTH follow the GARDENER to the new patch]* Is it, though? Look, I'm all for discipleship and pursuing God, spiritual disciplines like daily Bible reading and prayer and so forth. But I don't think in the Bible it is *ever* seen as a competition between loving God and loving others.

GARDENER: *[pauses weeding, eyes narrow]* What do you mean? Scripture is clear. Hebrews 12:14 says, 'Strive for peace with everyone and for the holiness without which no one will see the Lord.' David says in Psalm 24:3–4, 'Who shall ascend the hill of the LORD? . . . He who has clean hands and a pure heart.' Holiness is the sine qua non for the Christian. God accepts no-one without it.

RUTH: Right. But where does that holiness come from? The Bible talks about us pursuing holiness, but it also talks about our holiness as *something we already possess in Christ.* In 1 Corinthians 6:11, Paul talks about the church community as those who have already been 'washed, sanctified [made holy] . . . justified' in Christ by the Spirit of God. Ephesians 5:26 talks about Christ

who has *already* sanctified his church through the washing of the word. Titus 2:14 talks about Jesus 'who gave himself for us to redeem us from all lawlessness and to purify for himself a people for his own possession who are zealous for good works'. We are called to pursue good works and live a holy life precisely because we have *already been purified, set apart as holy, by God in Christ*, because of Christ's atoning work.

TED: That is what Scottish Reformed theologian John Murray called 'definitive sanctification' – the holiness we already possess truly and absolutely in Christ.[8] It doesn't remove from us the obligation to live lives of obedience to God, but it does completely change our *motivation* for holy living. We pursue holiness out of gratitude to the one who has already adopted, cleansed and embraced us as his beloved children. So all this talk of pursuing God as though we didn't already have him (or, rather, as though he didn't already have us) in Christ undercuts what the Bible says and it produces an unholy anxiety in believers. It morphs God into a strict cosmic headmaster: 'You kids better measure up or I'll expel you so fast . . .'. But the Bible is clear: we pursue God in the security of the knowledge that he has pursued and found us first in Christ. That's the gospel.

This is not something all Christians agree on, but it is a major tenet that came out of the Reformation and something that most Protestant churches which hold fast to the Reformation affirm.

GARDENER: *[unimpressed, resumes weeding]* Interesting theological digression. But how is it relevant to the issue at hand: the real mission of the church?

RUTH: Of *course* it's relevant. The promise of God's sanctifying, sovereign grace makes *all* the difference in the world. If you already have the holiness God requires (in Christ), then there is absolutely no competition between your everyday pursuit of holiness and reaching out to love others (and cultural engagement as a way of learning how to understand their world).

GARDENER: I'm not altogether convinced. *[Starts working in fertilizer from a nearby bag]* A person should always set the pursuit of God through holiness over outreach to others. Loving God still transcends and relativizes all other loves.

TED: What *I've* read in the Bible (and my experience has confirmed this), is that love for God and love for others are definitely not in competition. Neither 'transcends' the other. Rather, they go hand in hand or not at all. In 1 John 4:7–12, John writes that true love for God is expressed primarily *through* true love for others. They dovetail into one another: if you love others, God's love is in you. If you're not loving others, you're not loving God. And that is the very definition of Christian holiness: loving engagement, not withdrawal. Christian holiness that is established by grace alone (and not by our diligent practice of ascetic disciplines, like starving ourselves of culture) will necessarily flow outwards to others.

The character of gospel holiness is one of generously pouring ourselves into the lives of those around us, just as Christ generously poured out his life for us and served us so that we might become 'the righteousness of God' (see Philippians 2:4–8; 2 Corinthians 5:21). Far from being in competition, pursuing holiness and love for God requires love and service to others. 1 John 4 is quite clear: any holiness that does *not* express itself in love for other human beings is a sham holiness, a sham love for God. You cannot have one without the other. The love of God is properly expressed through loving others, even others in the world.

GARDENER: You think we're hypocrites and Pharisees: all law, no grace!

RUTH: Not at all. But it *is* true, legalism can be an Achilles' heel for intentional communities, especially conservative Christian communities, and legalism always produces toxic dynamics, including hypocrisy. The only antidote is the gospel, understanding that even our holiness is by grace alone, from God who 'works in us' (Philippians 2:13).

TED: And *that* means contact with the outside world is no threat. In fact, building bridges through cultural engagement actually helps us understand our non-Christian friends and neighbours better. It helps us to fulfil the law of love, to love them better in word and deed, as any good ambassador of the King should (2 Corinthians 5:20). Cultural engagement, properly understood, flows from a holy love of God and people. An overall strategy of cultural withdrawal isn't really an option.

GARDENER: *[sprays pesticide on aphids on plants]* You're still putting kids at risk and it's reckless. Why not keep them sheltered until they're older?

RUTH: That's why adults have to be careful about what culture they expose their kids to. But you also have to watch out that you don't overprotect children. Wrapping your kids in cotton wool and *only* exposing them to Christian culture does not lead to holiness.

TED: I read a blog post from a young woman who was brought up evangelical, but left her church and abandoned the faith (they call it 'deconverting' now). She considers the Benedict option strategy of cultural withdrawal and says, 'Hey, that's nothing new. That's how I was brought up: strong church, good teaching in the gospel, home-school co-ops. But it didn't work.'[9]

GARDENER: *[stops spraying and turns round to face* TED *and* RUTH, *genuinely curious now]* Why not?

TED: Because, by the time she reached university age, she had been so shielded from non-Christian culture and ideas, she had no idea how to interact with non-Christians. And worse, once she did, she found that her community had only ever told her half the story when it came to things like evolution, gay marriage and other things. When she met a nice, committed gay couple and evolutionists who had answers for the arguments she'd been taught, she walked away from her parents' faith.

Sheltering our youth doesn't work because you can't shelter them for ever. Christian bubbles produce the exact opposite of

what we want – kids with a resilient faith. Instead, they shape teens with a fragile faith precisely because they have never been exposed to the challenges of a post-Christian world.

GARDENER: *[resumes spraying]* This proves nothing. Some Christian kids walk away from the faith no matter what their parents or communities do.

RUTH: That's true and it's painful when it happens . . . and a real joy if and when they return *[brief significant glance at* TED*]*. But doesn't it make sense to engage culture *with* your kids? Within limits, of course! If you can choose between building walls to protect your children and walking with them to equip them, isn't the choice obvious? Why would I want to pass up opportunities to walk through tough issues, real issues, with my kids? *That's* how the wisdom of the Christian story gets passed down from generation to generation.

If an intentional community can do that, then I think it's on the right track. If it keeps parents and churches from doing that, then I think the community is squandering God-given opportunities and shirking God-given responsibilities. I want to be part of raising up a generation of ambassadors and artists who are culture-savvy people-lovers.[10]

TED: *[turns to camera]* In this segment, we've been talking to the Gardener. Here are the issues we've covered.

[The GARDENER, *in the background, returns to weeding her garden, softly humming a Gregorian chant.]*

[Title onscreen: 'Ringing alarm bells?']

RUTH: *[to camera]* First, we questioned if advocates of this strategy of cultural withdrawal weren't being too alarmist in their assessment of the threat to the church.

[Title onscreen: 'Strong community or outreach: must we choose?']

TED: Second, we questioned if we really did have to choose between having a strong, intentional community – one that told its own story and passed on good practices – and outreach to non-Christians through cultural engagement. We doubt that these two are mutually exclusive options. We agreed with the Gardener that churches often do a poor job of passing on a deeply rooted Christian faith, but we also suggested that the faith can be passed on by understanding alternative stories that contrast with it, such as those found in popular culture. Understanding culture and how the Christian faith resonates with some parts of it and offers something radically different and better – this can only help our grasp of the Christian faith itself.

[Title onscreen: 'Conflicting priorities: holiness v. outreach?]

RUTH: While the Gardener insists that pursuing God and holiness must come first, we insist that holiness comes principally from God by grace. Not that we can ignore God's commands, but we obey out of gratitude for the holiness we have *in Christ*. Therefore, speaking of competing priorities, as if love of God and love of others were somehow in conflict, is mistaken or misleading at best. Real love for God *always* expresses itself in love for other people.

[Onscreen title: 'Bring up the next generation: wrap kids in cotton wool or equip them?']

TED: Finally, we talked about how best to pass on our faith to the next generation. It isn't by building walls that keep everything out. Rather, it is by judicious exposure to the ideas and cultural works of the world around us – walking with kids, talking with them, helping them grow into their faith, showing them how the Christian faith does measure up in a world that often dismisses it.

RUTH: To sum it all up, we don't think that either an aggressive posture that seeks to force conformity or a defensive posture that seeks self-protection first and foremost provide the answer.

TED: Rather, we would recommend building bridges by planting oases – works by Christians that invite in both believers and non-believers, creating space for both. We feel that this is more creative, positive and persuasive than either culture warring or sheltering-in-place. But planting oases well takes work and preparation. So that is the subject of chapter 4.

GARDENER: *[still weeding, but a little winded]* May I go now? This is, like, the sixteenth take and my back is aching.

TED: *[under his breath]* We're still rolling ... you want to do a seventeenth?

GARDENER: Actors' Equity shall hear of this.

Discussion questions

1 Are Christians too alarmist about the state of the world? Is the Christian church truly in crisis in post-Christian societies?

2 Even if the church is in crisis, is withdrawal from culture the best solution? Is self-protection a good enough reason for defaulting on the church's mission to be for the world?

3 What does it mean in practice for a church to be an 'intentional' or 'thick' community, a community that understands the depths of its own tradition? How can your church pursue intentional community better? How can you do so individually?

4 What is the true source of Christian's holiness? How is it possible to pursue intimacy with God in a secular-leaning world?

5 Must cultural engagement threaten either thick community or personal holiness? Discuss scenarios in which you think that it may and see if you can arrive at solutions that combine them.

6 How can you – as a church community and as an individual or family – break out of the Christian bubble?

Getting started

- All parents who want to pass on their faith to their children struggle with balancing protecting them from corrosive influences in the world and equipping them for eventual independence in the world. Parents, discuss specific examples of when that balance is hard to find. See if you can share wisdom with one another as to how best to train up ambassadors for Christ who are simultaneously full of integrity and wise about how to engage with the world.

- How many non-Christians do you and your children count among your friends? Invite a family over for a Saturday lunch or afternoon, just to hang out, enjoy one another's company and talk about life. Hospitality is a great way to get out of the Christian bubble.

- Find a film or TV programme that is generating 'buzz' on social media (not only among Christians but everyone). Watch that film or programme. Ask your kids to join if it is age-appropriate for them to do so (which means you may have to screen it first). Then talk about it. What issues were being raised, realities about life that ordinary people – Christian and non-Christian – struggle with? What does the gospel say about those?

Notes

1 This joke first appeared in Ted Turnau, 'Dialogues concerning cultural engagement', part 1, *Foundations*, vol. 70 (Spring 2016), <www.affinity.org.uk/foundations/issue-70/issue-70-article-2-dialogues-concerning-cultural-engagement-part-one>, accessed February 2023. We are *not* afraid to reuse quality comedic material.

2 The Gardener represents, albeit loosely, the position of Rod Dreher's *The Benedict Option: A strategy for Christians in a post-Christian nation* (New York: Sentinel, 2017) – that is, a strategy of withdrawal from culture in the interests of preserving a distinctively Christian subculture.

3 For more on moralistic therapeutic deism, see Christian Smith and Melinda Lundquist Denton, *Soul Searching: The religious and spiritual lives of American teenagers* (Oxford: Oxford University Press, 2005). We assume that there has been a similar pattern among young people in the UK.

4 'Chiaroscuro' is a drawing technique in which artists use strong contrasts between light and shadow to bring out the modelling and shape of the subjects in a dramatic way.

5 Verse suggested by Dan Strange in 'Not ashamed! The sufficiency of Scripture for public theology', *Themelios*, vol. 36, issue 2 (2011), p. 258, <http://tgc-documents.s3.amazonaws.com/journal-issues/36.2/Themelios_36.2.pdf#page=61>, accessed March 2023.

6 Ted Turnau, *Popologetics: Popular culture in Christian perspective* (Phillipsburg, NJ: P&R, 2012). For how to do this with kids, see Ted Turnau, E. Stephen Burnett and Jared Moore, *The Pop Culture Parent: Helping kids engage their world for Christ* (Greensboro, NC: New Growth Press, 2020).

7 James K. A. Smith, *Desiring the Kingdom: Worship, worldview, and cultural formation*, Cultural Liturgies, Volume 1 (Grand Rapids, MI: Baker Academic, 2009), especially part 1, 'Desiring, imaginative animals: we are what we love'.

8 John Murray, 'Definitive sanctification' in *The Collected Writings of John Murray, Volume 2: Systematic Theology* (Carlisle, PA: Banner of Truth Trust, 1977).

9 Libby Anne, 'I grew up in the Benedict Option: Here's why it didn't work', *Love, Joy, Feminism*, Patheos (1 October 2015), <www.patheos.com/blogs/lovejoyfeminism/2015/10/i-grew-up-in-the-benedict-option-heres-why-it-didnt-work.html>, accessed March 2023.

10 On wrapping kids up in cotton wool v. equipping them, see Ted Turnau, E. Stephen Burnett and Jared Moore, 'The chief end of gospel-centered parenting', *The Pop Culture Parent: Helping kids engage their world for Christ* (Greensboro, NC: New Growth Press, 2020).

4

The path of creative cultural engagement: planting oases

We need to plant oases – creative works that invite Christians and non-Christians alike into conversation.

How *should* we engage with culture, then? Is there a more positive path?

In chapters 2 and 3, we presented a couple of paths Christians tend to take that relate to cultural engagement: culture warring and with-drawal into our safe, subcultural spaces. Granted, we presented them through the mouths of fictional characters – a sort of 'sock puppet theatre'. We hope that we didn't distort the positions of real people. We hoped to present serious arguments against real positions people take, for we feel that Christians should follow a different path.

Christian cultural engagement should be hospitable (even treating enemies as friends) and persuasive (as opposed to coercive or self-defensive). And that means looking into creative cultural engagement: planting oases.

Confession time: we lied (sort of). This book isn't exactly a 'how to' for planting oases, like a recipe book. Truth is, there are many different ways to plant oases – as many different approaches as there are creative people.

What this chapter – and this book – are *really* about is this: what must Christian communities understand about imagination and creativity that enables the planting of oases? What should creatives understand about the sorts of cultural works that can plant oases? How can churches support those who plant oases well and consistently? We will discuss this in more detail in later chapters. For now, let us suggest some action plans (like a good manifesto should) that are essential to creative cultural engagement.

Learn to play the long game

Think of any significant controversial social position from the past several decades about which the public has changed its position over time: racial justice, same-sex marriage, trans rights and so on. Scratch beneath the surface and you will find not only advocates and organizations but also a community that has invested in young creative talent, often for decades.

Once upon a time, homosexuality in television or film was played for laughs – it was over-the-top comedy. The 1980s were not characterized by an openness towards alternative sexualities. But behind the scenes, the gay community was on the lookout for talented writers, actors, directors or producers of films and those who commission TV programmes. Slowly, bit by bit, gay characters became more realistic, more heroic, more . . . normal. Actors began to 'come out', it became more accepted to reveal that they were homosexual.

Along with the increased positive representation in entertainment, public attitudes towards homosexuality and gay marriage changed to acceptance and changes in the law followed. A different cultural logic was impressed on the public: love is love, live and let live, accept and celebrate difference.

Because the Bible teaches that sex is intended for the context of marriage between a man and a woman, we may not agree with that logic. But it's hard not to admire the tenacity, long-term vision and commitment involved in achieving such widespread cultural acceptance.[1]

The Christian church as a whole has nothing like that concerted, long-term vision when it comes to creative cultural engagement. What it has instead is a market-driven culture aimed at other Christians and artless propaganda.

What if the Christian church actively encouraged talented young people to go into the arts and entertainment? What if the church produced generation after generation of scriptwriters, novelists, actors and producers who sought to show what real Christians look like and storylines that show how complex and tricky some issues are, especially if we value mercy and human dignity? What if the church produced generation after generation of painters, photographers and cinematographers who captured beauty and ugliness, the joy and pain of human existence, in ways that gestured beyond what we see? What if the church produced generation after generation of musicians and singers who did more than praise songs, but wrote protests, laments and celebrations aimed at everybody, with tunes that got in your head and lyrics that were dangerously insightful?

The Christian church and the post-Christian world need subversive works of depth and beauty. We need oases. And we need a shared long-term commitment to the creatively gifted who can create oases.

If you don't hide your light under a bushel, expect entrenched resistance. Be patient and keep loving, praying and creating

It's no good at all creating culture only for the home team. Sure, there's a place for praise music in public worship and private celebration, but that falls far short of creative cultural engagement.

If we want to see the disconnect between church and culture bridged, we must support and look for Christian creativity in the mainstream. And when we venture into the mainstream, we must expect the cultural logic, the 'rules of the game', to be quite different from those in the Christian subculture. What we consider holy, they consider to be oppressive and vice versa. We should *expect* the odds to be stacked against Christian creatives. In a post-Christian world that sees Christian freedom as authoritarian slavery, how could it be otherwise?

And yet, that is the world we are called to engage. There is a virtue in rubbing shoulders with those alienated from God, working alongside them, befriending someone who sees life quite differently from you. These are people we are called to love.

Non-Christian fellow creatives may well come to see you as human, not a mortal enemy after all. There's no guarantee, but prayer and patience may bear fruit, God willing.

Art and entertainment institutions, however, are another matter. Within a capitalist consumer economy in which arts and entertainment are considered commodities, supply and demand rule. This means that institutions will be ruthless in their dealings with those they feel threaten their bottom line.

This calls for patience on the part of creatives and those who support them. Overturning the predominant cultural logic is a slow, difficult task. Do not succumb to discouragement. Keep loving those in your relational circles. Act with integrity always (not a given in the entertainment industry). And keep creating, praying that God

will allow your tiny cultural subversions to see the light of day. Despise not the 'day of small things' (Zechariah 4:10). Neither Rome nor the temple were built in a day.

Resist the urge to compromise *or* retreat and retrench

Life is not easy in Hollywood or anywhere else for a Christian creative. We both know people in the entertainment industry and they tend to keep a low profile. One actress told me that if you're heard saying something like 'Jesus is the only way to God', you're finished. An errant tweet could end a career.

Christian creatives live in this weird, stressful in-between space where they must always proceed with caution.

Caught between competing cross-pressures – your faith saying to go in one direction, culture and the industry saying to go in a different direction – creatives face a two-headed temptation.

On the one hand (head?), creatives will be tempted to mute their faith to the point of non-existence. Any opinion that runs contrary to the prevailing cultural orthodoxy will be silenced and altered to fit the temper of the times. If creatives choose the path of lesser resistance, over time their perspective may well change, so that they can affirm, 'Yes, love *is* love, no matter what gender is involved.' The end result is a compromised Christian faith.

On the other hand, creatives may be tempted to run for shelter, to hide in the safety of the Christian subculture. The Christian film or music industry is far less stressful – no more swimming upstream. But that, too, will change creatives. Given the freedom to speak out, opinions may become dogmatic. Perspectives (and hearts) may harden as compassion for the lost fades. Creatives may then default to culture warring or retreat to a walled garden. The end result is a Christian faith that burns rather than builds bridges.

When creatives either drift from a solid faith or run for cover into the safety of a subculture, the blame does not belong to them alone. Churches bear some responsibility for whether creatives flounder or flourish. The wider Christian community often has little to no understanding of the difficult path trodden by those on the front lines of creative cultural engagement. Curiosity from church members about what creatives' lives must be like can lead to prayer and encouragement. Pastors should take time to research the arts and entertainment industries that their church members are involved in. Pastoring artists is different from pastoring those who are builders, medics, electricians or who do almost any other type of work. Both pastoring and encouragement from brothers and sisters are essential for the long-term faithfulness and compassion of Christian creatives. Support from the wider church is also vital to bringing this long-term vision to life.

Focus more on creative culture than cancel culture

Artists and those in other creative industries receive pressure not only from mainstream entertainment companies but also from Christians. Conservative Christians, too, are overly eager to cancel those they consider to be beyond the pale. In an age of social media hot takes, Christians are way too trigger-happy.

In the late 1990s, one of the biggest Christian musical artists among evangelicals in the USA was cancelled. Amy Grant got divorced (never mind that her husband had a full-blown drug addiction). Worse than that, in the eyes of many evangelicals, five years before her divorce, she went *mainstream*, daring to use her Christian voice to sing about romance.[2] For many, that threatened the assumed (but ultimately unbiblical) sacred–secular divide.[3]

The truth is, Christian creatives are sinful, fallible people. They are broken. They mess up. They struggle. And they repent – just like

the rest of us. The real difference is that some of them become famous and therefore live in the public eye. That opens them up to criticism, scandal-mongering and heresy-hunting, whether there is anything there or not.

Sometimes, it isn't a lapse in character, simply a difference of opinion. A friend told me about a musical group that got cancelled by Christians because its members let slip that they didn't believe in a literal seven-day creation. Others have been cancelled because of views on masking and vaccines during the COVID-19 pandemic or regarding race and politics. It seems as though Christians are so anxious to be seen as supporting the 'right' beliefs and policies that they are willing to destroy others' careers over them rather than show charity and acknowledge that Christians don't agree on everything.

My (Ted's) father used to say that the Christian church is the only army that regularly shoots its own (and its wounded). That is not Christianity. That is tribalism at its worst.

We can and should be more gracious than this.

Obviously, there *are* times when Christian leaders, especially pastors, should be removed from their positions, such as in cases of abuse, serious misconduct or betrayal of trust.

Artists are *not* ordained leaders of congregations. Their failures will not sink or divide churches (or they shouldn't). But because they often have more visibility than your average Christian, we may confuse them with Christian leaders. We may think of them as pastors. They are not.[4]

If we make a habit of cancelling them for failing to live up to our expectations and opinions, that absolutely undermines the possibility for creative cultural engagement, for planting oases.

Wouldn't it be more in line with biblical charity if we didn't automatically consign our opponents to the pit of hell for the speck in their eyes, ignoring the logs in our own (Matthew 7:1–5)? We must think twice, three times even, before firing off that angry

tweet cancelling an artist or entertainer. (The lack of Christian charity shown is a whole other topic, but very much related to this one.)

Wouldn't it make more sense to support Christian artists in times of crisis? Why not assume that they have a pastor or more mature Christian friends who are dealing with a lapse and seeking to draw them to repentance? We should *want* to see them growing in grace and wisdom, and sometimes that comes after travelling along a rough road of personal failure. We want to see them as ambassadors for Christ, working in mainstream culture alongside people who have very different beliefs from theirs. Being ambassadors does not make them (or us) flawless moral figureheads. We are all, together, broken people who depend daily on God's grace for forgiveness when we stumble, and continued faithfulness when we don't.

Actively supporting and praying for those in the art and entertainment fields takes patience and an open mind. It takes discernment to sift between what could threaten the essentials of our faith in Christ and what is merely weird and uncomfortable. Perhaps an artist has blue hair and piercings, hangs out with those you consider disreputable and draws images in a style that you find disconcerting. Are those reasons to distance yourself from that creative person? Perhaps the artist has reasons for doing those things, reasons you, as a non-artist, might find hard to understand.

A friend of mine worked as a barista years ago. He did an experiment. He had his nose pierced. As soon as he did that, the tattoo and piercing crowd felt comfortable chatting with him, while those who looked more clean-cut didn't want to engage. Then, some months later, he removed the piercing and the clean-cut people now felt comfortable chatting with him, while those with tattoos and piercings stopped.

My takeaway from this? Christians, get comfortable talking with people who look freaky to you, especially if they are brothers or

sisters in Christ. They are on the front lines, befriending and collaborating with freaky-looking people all day long.

You must trust them as a people who seek to follow Jesus in good faith and have gifts that place them in a strategic position for engaging mainstream culture.

Later, in chapter 8, we will explore how we can support artists. For now, let us agree that we should, in principle, support those who are making efforts to follow Christ in good faith in difficult and often hostile circumstances.

They don't need our hostility as well.

Christians must be intentional about supporting and embracing creatives – even (especially) when we don't understand them. That is so much better than cancelling them out of spite that we mistake for spirituality.

Be prepared for sacrifice, vulnerability and brokenness

Turning away from the comforts of cancel culture has everything to do with our cultural 'posture', both as creators and as audience. Christians in a post-Christian world must attend to their posture.

Are we sitting in church scowling, powdered wigs in position, looking down our noses in judgment on whatever cultural work passes before us?

Or are we actively walking the multiple paths that culture presents, drawing alongside our fellow travellers, sharing pains, discoveries and hope with the broken, offering a supporting arm to those who are in danger of stumbling? That, we submit, is the *biblical* posture we should adopt towards the surrounding culture, because we know that we ourselves are broken, works in progress, on the way to becoming whole.

The first posture is full of pride, ready to judge. It will inevitably build walls. The second is more self-aware, so walks in humility. That

is the posture of the 'poor in spirit' (Matthew 5:3). That posture builds bridges.

But it also demands more, especially from creatives. It is a posture that costs them, and us, dearly.

Let us be clear: we are not advocating an uncritical embrace of any and every cultural work. There are works that Christians should rightly steer clear of. But, rather than being quick to judge cultural works, Christians should understand – from a posture of humility – that even works that trouble or disturb our sensitivities are made by human beings, humans who are broken and need mercy. We connect with those alienated from God and the church by understanding that we are broken as well. A posture of vulnerability speaks volumes to a population who assume Christians are arrogant and despise everyone not like them.

I (Ted) had the chance to interview the Christian creators of a computer game called *That Dragon, Cancer*. The game allows you to walk with two parents who struggle with their faith as they watch their youngest child die of an inoperable brain cancer. You hear their arguments, their prayers and their tears – all of it. Ryan Green, the father of the child and lead game developer, called the process 'becoming transparent'. What a powerful phrase! This couple let the world in to see them at their most vulnerable.

While taking the beta version of the game to conferences and letting people try it out, Ryan said that people's responses were remarkable. Atheists and agnostics wept with them, often sharing stories of their own pain. It led to conversations in which they could share God's love for them as their Father.[5]

Oases are planted and grow watered by their creators' blood and tears. The process costs creators dearly. It demands that we, like they, abandon postures of self-protection and open ourselves up to showing our wounds so that those alienated from Christ might recognize us as fellow humans – imperfect, warped, but hoping in a God who heals.

Together, learn to embrace the depths and heights of imagination – creative cultural engagement should be *everyone's* business

That last point was aimed mostly at creatives, the ones with the gifts and training to plant oases. But surely sacrifice, vulnerability and a sense of our own brokenness aren't the special province of artists alone. These should characterize *everyone* in the Christian community. Christians are those called to a life of self-forgetting sacrifice, vulnerability before God and others and the humility to recognize that we are broken and desperately need God's mercy (as do the non-Christians around us – we're no better than they). To put it in modern parlance, we're to vibe like self-aware, humble Christian creatives do. All of us are on display before a watching world – attitudes of cranky self-protection or sentimental self-insulation from the outside world aren't really options for faithful Christians.

What we're talking about is 'emotional amplitude' – how broadly and deeply we allow ourselves to feel things. That is what the imaginative life trains us for. Genuine oases – creative works that can resonate and touch the hearts of both Christians and non-Christians – help to lead us to be more deeply in touch with our own scars and deep delights, and to understand the scars and delights others carry. We all bear wounds that we'd rather not face, darkness within and without that we have a hard time finding words to express. All of our hearts harbour joys that seem to surpass what we can articulate. Imaginative works can help to lead us into ways of understanding and articulating those sources of light and darkness that all humans deal with.

Oases can therefore help us to grow in compassion for others and in appreciation of God's compassion for us and his generosity towards us. It can help us to connect with others going through hard times and open us to others who offer to walk beside us when we are going through hard times.

Embracing emotional amplitude through an imaginative life has a positive impact on the witness the church gives in a post-Christian world in at least two ways.

First, most non-Christians have an image of Christians as fairly unimaginative, narrow-minded people. We have our own narrow interests, agendas and comforts (taking refuge in what they see as an archaic fable), but not a lot of mercy and wisdom. That image is, in part, distorted secular propaganda. But too many Christians do fit that profile.

How refreshing and delicious it would be to explode those stereotypes through face-to-face encounters and relationships in which each of us manifests winsome wisdom, empathy and a creative spark that leads to deeper friendships. What if Christians became known as people you *want* to hang out with because they are so engaging and faithful as friends? Learning the paths of imagination (which includes, among other things, the ability to put yourself in another's shoes) helps us to walk alongside non-Christian friends.

Second, if the Christian community starts to fully learn about imagination and creative engagement, they will be a better support – in prayer, finances and encouragement – to the creatives who plant oases. Artists and other creative professionals cannot do this alone, especially if they are working in the mainstream (where they can have a widespread impact) and not in the Christian subculture. If the church wishes to sustain creative cultural engagement in the long term – and this *is* a long-term vision – it must be willing to walk alongside creatives and provide support and wisdom. Creatives need culture-savvy, Spirit-led allies.

This means, of course, that creative cultural engagement concerns all of us, not just the artists. We all need to learn what the imagination is, what makes the Christian imagination distinctive, what art is and what it's for, what makes for oases and what makes for propaganda or sentimental failed art. This is a call for churches

to become greenhouses for growing imaginations, schools where imaginations are nourished, strengthened, trained and shaped. Churches can do this in a thousand different ways: imaginative preaching, film nights with discussion, arts nights, book clubs, Sunday school classes (ones for children *and* ones for adults), worship and more.[6]

Embracing the imagination helps the wider Christian community to learn how to spot excellently crafted oases – those works the beauty and depth of which resonate with Christians and non-Christians alike, which are so vital to creative cultural engagement. We might even learn to value them and what they can do more than what's comfortable and familiar.

Our relationship with the imagination is the hinge on which our cultural engagement swings. And that is the topic of chapter 5, 'What is the imagination?'

Discussion questions

1 What needs to happen (in terms of attitudes, priorities and institution-forming) for the church to 'play the long game' of creative cultural engagement? What are some first steps that you can encourage in your local church?

2 If you know any Christian creatives, ask them where they feel the cross-pressures between their faith and the secular creative world most keenly. Where do they feel the temptation to compromise or retreat?

3 Ask creatives you know how you can best pray for them. Ask them what you could do to help them feel supported and valued as brothers or sisters in Christ.

4 Talk about Christian cancel culture. Where have you been tempted to cancel a Christian artist (or any Christian)? How can you combat that impulse?

5 Suppose you see a Christian artist or entertainer cross a line (for example, in an interview, saying that Jesus is one of many

ways to God). What are some ways that you could respond that don't simply involve cancelling the artist? What steps could you take that would be more productive (such as praying for them, engaging them in conversation on social media . . . without simply condemning them)?

6 What do we mean by 'cultural posture'? What cultural posture do you observe at your own church? In your own heart? How do you go about inculcating a posture of humility and kindness rather than one of fear or arrogance?

7 If you have any Christian artists or creative friends, ask them if there has been a particular work that cost them something in terms of emotional energy or vulnerability and talk about it.

8 Think about works of art – fiction, films, paintings, songs, games – that have moved you and helped you feel deeply. Describe what moved you and what you think it touched within you (if you feel safe sharing that with others).

Getting started

- All of us face workplace tensions to some extent, but perhaps not like artists and those in the creative industries. If you know someone who works in a creative field, take the opportunity to go out to lunch and ask about what it's like. What is most difficult? Ask them questions 2 and 3 in the 'Discussion questions' section. (If you don't know an artist, your assignment is to find someone who is or at least read about a featured artist on Rabbit Room or Morphē Arts on the Internet.)

- If you are a pastor and have an artist or someone working in the creative industries in your congregation, do some reading about that person's particular medium and genre. If you don't know where to start, try asking the artist for a recommendation. You can also find some recommended reading at the back of this book.

- See if you can find people in your church who would be interested in the arts and imagination. Set up a meeting. Brainstorm some concrete steps that you can take in the near future to pursue a more robust imaginative life, individually and in your church.

Notes

1 To be clear, we affirm the biblical norms for sex and marriage (heterosexual monogamy). We also affirm the biblical command to love those who reject God's norms. For a nuanced and imaginative approach to biblical standards for sexuality, see Glynn Harrison's *A Better Story: God, sex and human flourishing* (London: IVP, 2016).

2 For details of the Christian cancelling of Amy Grant, see Jonathan Poletti, 'Amy Grant's divorce from hell', *Medium* (16 September 2020), <https://medium.com/be<lover/the-shaming-of-amy-grant-3f8327c36803>, accessed March 2023. (It got messy.)

3 We don't have room to go into detail here, but it is helpful to remember that 'secular' is not a biblical category – it's an invention of the modern West. If Jesus is Lord of *all* of life, then there can be no truly secular areas of life. All of it – your job, homework, sex, car maintenance, changing your baby's nappy – is (or should be) *sacred*, spiritual. That is, done in a way that pleases the Spirit. If it is not, if it is done in a sinful, selfish way that runs counter to God's will, then it's not 'secular' but *desecrated* (a ruining of something sacred).

4 This is a tricky topic, as famous Christian entertainers do have cultural influence, a certain power. Nevertheless, they are still lay Christians, not ordained pastors (most of the time). That makes a difference – they ought to be under the authority of the church's leadership, as all Christians should be. Cultural influence is not the same thing as spiritual authority, though these days the two are often confused.

5 I explore *That Dragon, Cancer* in more detail in chapter 12
 in *Oasis of Imagination: Engaging our world through a better
 creativity* (London: IVP, 2023).
6 We will mention many practical ways Christians and church
 communities can support creatives in chapter 8.

5

What is the imagination?

Imagination is an important part of how God made us.
We need to understand how 'the eyes of the
heart' shape both how we perceive the world
and how we create new worlds.

Pursuing the path of creative cultural engagement means that we must understand what the imagination is – no easy task.

The imagination is that unruly kid who sits at the back of the classroom, doesn't always follow the rules and sometimes makes left-field comments. Because of this unruliness, conservative Christians have often treated the imagination (not to mention imaginative people) with suspicion. Some find outside-the-box thinkers threatening to orthodox belief and godly living.

But consider this: the Bible itself is bursting with imagination. It contains stories told with vivid, surprising details – a dream with fat cows and thin cows, the exact size of the pole Haman was impaled on (50 cubits, approximately 23 metres, if you were wondering), the colour of God's throne, pomegranates that adorned the tabernacle, fathers sprinting down the road to embrace long lost sons, bodies with many parts that all need one another, a red dragon with seven heads and ten horns, and on and on.

Dismiss the imagination and you end up dismissing most of the Bible.

Still, Christians down the ages have harboured suspicions about those who make their living in the fields of imagination: writers, painters, musicians, actors, dancers. To be fair, imaginative people can be . . . weird. They dye their hair odd colours. They sometimes get tattoos or piercings or dress in unconventional ways. And they can sometimes make life choices that leave us scratching our heads. But they are often wonderfully down to earth, often have stable marriages and often raise kids who love the Lord.

In other words, beware putting imaginative people (or any people for that matter) in a box. They come in all shapes and sizes. And they are absolutely essential to the church in a post-Christian world. They live at the front lines of cultural engagement.

Creatives are our bridge-builders, our oasis planters, our interface with a world that doesn't know – or care to know – Jesus.

In the interest of understanding them better, as well as enjoying and engaging the imagination more fully, let us take some time to explore what the imagination is and what makes any imagination distinctively Christian.

As Christians, when we want to understand anything, we turn to two sources: the Bible and nature (in this case, human nature). Let's consider each in turn.

What does the Bible say about the imagination?[1]

The most obvious place to start is that God is the Creator, an imaginative one at that. Go watch a nature documentary. God's imagination must be *massive*: hedgehogs, deep-sea fish with glowing lures and razor-sharp fangs, Venus fly traps, anvil clouds, pumice rocks, and on and on!

But his imagination is displayed not only in creation but in salvation as well. He created light from darkness, life from death, eternal beauty from the ugliness of his Son's broken body on the cross. He wove mercy out of a miscarriage of justice. And out of a sinful mob of misguided sheep he is crafting a people, loved sons and daughters eager to do justice, love mercy and walk humbly with their God (Micah 6:8). All of this from his sovereign imagination!

And we are made in his image (Genesis 1:26–28). Our imaginations are fashioned after his; our creativity is an echo of his infinite and completely original imagination. We are his mini-creators. But, of course, our imaginations are not simply carbon copies of God's imagination. We must ask how our imaginations are both like *and* unlike God's.

How is our imagination *like* God's imagination?

We share a certain freedom of imagination

We can imagine just about anything.[2] Yes, our imaginations are derivative, mediated, but there is still a ton of freedom there.

Like God's, our imaginations create 'homes' for us to inhabit

God's imagination made a home for us – namely, the whole earth and everything in it. Our imaginations do the same, though on a much smaller scale. Of course, we build physical homes with architectural

imaginations. But we create fictional, imaginary worlds and homes too. Whenever someone weaves a story or we play a game or get lost in a song, our imaginations are captured in that imaginary world – it becomes our 'home' for as long as we enjoy the story, game or song. Like God, we use our imaginations to create home-worlds.

How are our imaginations *different from* God's imagination?

But there are also deep differences between God's and our imaginations, since we are not gods.

We cannot make something from nothing

We need the stuff he made – wood, pigments from plants and oil, glass made from sand for camera lenses – if we wish to make anything. That is, our creativity is *mediated* through God-made stuff. Even spoken-word storytellers depend on created stuff to express their imaginative works. They need air to carry the sound waves, food to sustain themselves, and generations of stories, real and fictional, to draw on. Even fantastical images that live in our heads alone are derived from stuff we've seen: centaurs from horses and people, grey aliens that look like children and so on.

That is, our creativity is *derivative*. It draws from God's original creativity. We need his creation to create. God didn't (and doesn't) need anything. He simply exists in joyful communion as the three persons in one God, the Trinity.

God's creation is effortless, without a struggle through time; ours is not

In Genesis 1, God speaks and, poof, light, sky, water, land and animals simply appear.[3] Other creation stories of the Ancient Near East all contain struggle because chaos (the forces of anti-creation) fights back, there is a war between gods and so on. From a biblical

perspective, creation does not fight its God. It does fight us. We struggle to bring what we have in our imaginations to tangible expression. We must knead the clay, learn the instrument, rewrite sentences and reshoot scenes. Our creation is mediated not only through stuff but through time as well, in a way that God's is not.[4]

Our imaginations are bent by sin

The products of our imaginations are often distorted, impure and malign: films that inflame lust, stories that slander, games that glorify brutality, dreaming up revenge scenarios, not to mention the real crimes that start as twisted imaginative seeds. Unlike God's, our imaginations are *fallen*.

God perceives reality 'straight up', unmediated, pure. Our perception of reality is always already filtered through and coloured by our imaginations

That is what Jesus meant in Matthew 6:22–23 when he said:

> The eye is the lamp of the body. So, if your eye is healthy, your whole body will be full of light, but if your eye is bad, your whole body will be full of darkness. If then the light in you is darkness, how great is the darkness!

The 'eye' Jesus refers to isn't simply the physical eyeball or visual perception. It's the 'lamp of the body', guiding the whole person. Our imagination, our 'lamp', invests the world with meaning, guiding us through meaningful action. If that lamp goes bad, then 'how great is the darkness!'

Paul speaks of the imagination as the lens through which we experience the world in Romans 12:2 when he says, 'Do not be conformed to this world, but be transformed by the renewal of your mind.' It's what he prays for in Ephesians 1:18 when he asks that God

enlighten the 'eyes of your hearts' so that we may know the hope and riches of salvation that God has called us to.

What does it mean to see through our imaginations, our 'eyes of the heart'? It means that, depending on the state of our hearts, we see the world as dead and godforsaken, or as it really is: under God's control, warped by sin, heartbreaking, to be sure, but moving towards healing and redemption in a new creation.

Our imaginations, our eyes of the heart, colour everything we see. We learn to see our spouses not just as they are but as they could be, even when they disappoint us. We can see them as God sees them – as forgiven sinners in whom he is working – or we can see them as lost cases and cynically give up hope. We can see our kids as distractions and annoyances, or as younger brothers and sisters entrusted to our care, growing in grace and truth. We can see our jobs as tedious treadmills for earning money, or as a calling that God has prepared for us beforehand (see Ephesians 2:10). The eyes of the heart train our minds to see everything in one way or another: as doomed to futility, or budding with grace and potential for beauty.

Is God's imagination different? Yes: God looks at the world and always sees it as it truly is every single time. Even more, reality conforms to his imaginative sight in a way that it doesn't for us. When we look at the world, when the eyes of our hearts are pulled towards despair or the bright glitter of idols, we (unlike God) really do need a renewal of our imaginations to see the world the way it really is.

Our default setting is unbelief and delusion. We need divinely empowered imaginations to see reality as it is – that is, conformed to God's imagination, God's 'eyes of the heart'.

In the Bible, then, the imagination is not only about creating new things (stories, songs, works of art). It filters our perception of reality, of what already exists.

What does human nature (interpreted by science and philosophy) tell us about the imagination?[5]

The Bible is, of course, not the only way that God communicates truth. He also shares wisdom with us through nature – in this case, *human* nature. Let us hear from scientists and philosophers regarding what they have observed about the imagination.[6] Here are a few points to take away, insights that resonate with what we've already gleaned from Scripture.

The imagination isn't simply a product of conscious thought. Rather, the imagination is deeply interwoven with our bodies and emotions

Christian philosopher James K. A. Smith notes that our imaginations are shaped by preconscious disposition, habit and upbringing.[7] The imagination is a thing of the body as much as it is of the mind.

Artists know from experience that the imagination is seated in the body – they work by 'feel' as much as by 'thought'. They play that run of notes, add that pigment or that word in a line of poetry, because it 'feels right'.

Consider also how the imagination can have a compulsive side, a side that's not in our conscious control. Stereotypes work in this way – we may not *want* to make unfounded assumptions about a person, but we do nonetheless.

Or consider those who have suffered a trauma or from anxiety. The imagination goes on an auto-piloted overdrive, presenting memoires and scenarios that they don't want before their mind's eye.[8]

However, the imagination is not simply a thing of the body. It is also a thing of our minds, of conscious reflection. We can and do 'talk back' to our imaginations. We question assumptions, argue with our anxieties, soothe past traumas. We even consciously guide what we see and hear in our mind's eye – we call this 'daydreaming'.

Imagination, therefore, is a conversation between the unconscious and conscious mind, between wired-in bodily/emotional reactions and consciously chosen thought.

The imagination has two aspects: creative and perceptive

As we saw in our brief exploration of what the Bible says about imagination, cognitive scientists and philosophers recognize *two aspects of the imagination*: that it is the key to creativity *and* something that organizes, filters and colours our perceptions.

The perceptive imagination has to do with how the imagination shapes the way we experience the world around us

We do not mean that our senses don't really perceive the world outside of us. Our eyes see, our noses smell, our fingers feel and so on. But it's not simply a passive process. Our minds construct mental imagery, sift images into categories and invest what we see with meaning, often filling in the gaps in imagery.[9] This meaning-making whirs in the background without drawing attention to itself. It becomes noticeable when it misfires, when we 'see' things that *would* make sense but aren't actually there. I cannot tell you how many times I've seen Loki (the Turnaus' black cat) out of the corner of my eye. I turn my head and it's an empty dark corner. My imagination interpreted visual information according to what I expect to be there . . . but isn't. Once I give it my full attention, then my imagination corrects its mistake and there is no cat. It is odd, but that is how our minds organize the sensory information they receive – through our imaginations.

All this is necessary for us to make the world meaningful and habitable. In a sense, we must imagine the world as we perceive it. We see through physical eyes as well as the eyes of the heart.

The creative imagination enables us to bring new things into the world – new 'worlds of meaning' – and to enjoy them

The imagination not only filters perception, it also drives us to create. That is what we typically think of as 'the imagination'. It helps us to see the world that exists (and make it *our* world). But it also enables us to create new things, new worlds . . . and to enjoy what we create. That is, it takes imagination to see what is but, more than that, it takes imagination to project what *could* be, the way the world *should* be. It is this last that is where we get our sense of injustice from – seeing the gap between the world as it is and the world as it ought to be.

When a storyteller tells a story (in whatever medium – film, song, computer game), that story projects an imaginary world, an alternative universe, according to language philosopher Paul Ricoeur.[10] It takes imagination to create works that project worlds.

But it *also* takes imagination to project ourselves *into* those worlds, to live in an imaginary world for a while. We experience other people's imaginations only by exercising our own imaginations. If we wish to tramp along with the hobbits, to walk a mile in their furry feet, we must *become* hobbits ourselves (at least in our imaginations). We do this without noticing, but it is quite an imaginative feat to put on other feet. You must leave your kitchen or living room behind and travel to a place that exists only in fiction, into the head of someone who was never born except through pen and paper. In a sense, you must become a sort of co-author with Tolkien or Spielberg or whoever is telling the story.

The creative imagination both creates worlds and transports us into those created worlds.

Perceptive and creative imagination are intertwined through metaphor

These two aspects of imagination – perception and creativity – bleed into each other, like wet watercolour pigments on a page, because they draw from the same well: metaphor, seeing-as.

'Metaphor' is simply the ability to see one thing in terms of something else. It is the engine that drives poetry – seeing my love as a red, red rose and death as a sunset . . . or even seeing poetry as a car that has an engine.

Our seeing-as goes far beyond poetry, however. Metaphor is the imagination's way of transforming the world for us, making it ours, making it our home. When the imagination filters perception, it gives the world an emotional 'expression', a mood or tone. Philosopher Kathleen Lennon says that the imagination gives the world a 'physiognomy', an expression, like the expression on a face.[11] So our imaginations, using a sort of blanket metaphor, give us the world as full of emotional texture. We see the world as brooding and lonely, or as vibrant with life and hope. We see our jobs as battlefields, or playgrounds, or torture chambers. We see our spouse as a ball-and-chain, or a comrade-in-arms, fellow explorer or, perhaps, we barely notice him or her at all. Our whole world gains emotional texture through a metaphorical transformation thanks to our imaginations. (We looked at this in biblical terms as the 'eyes of the heart').

When the imagination creates something new, it likewise employs metaphor, seeing one thing in terms of another. It transforms words into a story-world, tones into a song, light and shape into images that convey something deeply meaningful. The imagination uses metaphor to create new meaningful patterns for us to share and experience.

The imagination's targets in its work of perception and creation are different – the real world versus the creation of new meanings in art – but the process is the same. The imagination wields metaphor to create (or discover) new meanings and resonances about the world.

What the imagination creates has the power to shape us and how we perceive

That is why the ways in which we create and enjoy creative works matters. When we spend time in an imaginary world, it changes us. We return to the real world with slightly different 'eyes of the heart'.

Our time living in an imaginary world alters our 'imaginary landscape' – the hopes and dreams, anxieties and fears that create the context of our thoughts and actions, the context of our lives.

That is what makes discernment in what we watch, listen to, read and play so important. The kinds of stories we inhabit shape us.

It is also why it matters what kinds of cultural works we create – excellent or shoddy, bursting with creativity or painfully banal. Those will shape others, for good or ill.

The imaginary worlds projected by oases can also have a tremendous impact on the people who inhabit them. Would we prefer to invite outsiders and strangers into a world that could potentially change their lives for ever? Or, do we prefer to create solely for our own subculture and have precious little impact on those outside it? The choice is ours.

Discussion questions

1 What attitudes have you noticed in your own church (or your own heart) regarding artists and creatives? Do you know any Christian creatives who live down-to-earth, faithful lives?

2 Take a moment and thank God for the gifts of his imagination displayed in both creation and salvation that make our lives so wonderful.

3 Where do you feel the need for a renewal of your 'eyes of the heart'? If it's something you feel safe sharing, discuss this with one another.

4 Think through the connection between creative and perceptive imagination. Are there creative works that have shaped the way you perceive the world? What were they and how specifically did they shape your perceptions?

Getting started

• Do a word study in the Bible on the heart, looking at all the times that it is mentioned. How does it relate to thoughts,

actions, desires and feelings? What connections can you see to the imagination?

- If you are a church leader (or can suggest it to your church leader), consider interviewing creatives within the church occasionally as part of the service. You could ask, how do they use their imaginations in what they do? How can the church support them?
- Why not try using a creative journal to help you to develop your own imagination? Jot down ideas, sketches, snatches of writing or drawing that might be the seeds of new projects.

Notes

1 For a more detailed exposition, see Ted Turnau, *Oasis of Imagination: Engaging our world through a better creativity* (London: IVP, 2023), chapter 5.

2 I would draw the line at logical impossibilities. It is impossible to visualize things such as square circles and triangles with five sides and so on in the imagination.

3 We are intentionally focusing here on creation as presented in Genesis 1. If God used an evolutionary process (called 'theistic evolution'), then God's creation would also involve time – a process spanning millions of years.

4 In creating our redemption, however, time and struggle were involved. In that case, fallen creation *did* fight back (or, rather, the image-bearing part of creation rejected God). So creation took time. The garden at Gethsemane took time. The crucifixion took time. We waited three days for the tomb to be empty. It blows the mind: God, the eternal and omnipotent, struggling through time to save his sin-twisted, time-bound creatures.

5 For a *lot* more detail, see Turnau, *Oasis of Imagination,* chapter 6.

6 There are many, often conflicting, theories, so we have had to be selective. The ones included here are some of the ones that make sense to us as Christians.

7 See his *Imagining the Kingdom: How worship works*, Cultural
 Liturgies, Volume 2 (Grand Rapids, MI: Baker Academic, 2013),
 chapters 1 and 2.
8 See Jim Davies, *Imagination: The science of your mind's greatest
 power* (New York: Pegasus Books, 2019), p. 248.
9 Davies, *Imagination,* chapter 2, goes into great detail about how
 imagination filters perception and memory.
10 See Paul Ricoeur, *Time and Narrative*, Volume 1, tr. Kathleen
 McLaughlin and David Pellauer (Chicago, IL: University of
 Chicago Press, 1984), chapter 3.
11 The phrase was coined by French phenomenologist Maurice
 Merleau-Ponty, and is quoted in Kathleen Lennon, 'Re-enchanting
 the world: The role of imagination in perception', *Philosophy*,
 vol. 85, no. 33 (July 2010), pp. 375–389.

6

What makes an imagination Christian?

A Christian imagination that plants oases in a post-Christian world must express the tension between the darkness and the light, and find a proper balance and resonance between shouting its message and mumbling incoherently.

If imagination is the faculty that transforms our world through metaphor and creates new imaginary worlds, also through metaphor, what makes the Christian imagination different? What 'seeing-as' shapes the way we experience the world, as well as the matrix from which we create new works of art and entertainment?

Think of the imagination as a pair of glasses with coloured lenses. How does a Christian faith-shaped imagination colour your world? What sorts of things jump out or blend in? Just as important, what

kind of Christian imagination leads to a creativity that resonates with Christians and non-Christians alike in this post-Christian world? That kind of imagination plants oases.

It's a question of maintaining a tension and finding a balance.

Brightness control: the tension between darkness and light

How does the Christian imagination shape how we perceive reality and how we create? It's not as straightforward as you might think. The Christian faith is complex and covers all sorts of things. But we're not interested in the 'what' so much as the 'how'. *How* should the world appear to a Christian?

If we were forced to choose the central point of the Christian faith, I think Jesus' death and resurrection, cross and empty tomb would surely qualify. That's the hinge on which all history turns. And those two realities – that Jesus died a criminal's death for us and that, in Jesus' resurrection, God defeated sin and death – shape the Christian imagination.

The cross-shaped imagination: dealing with darkness

Christians understand that the world, though a wonderful creation, is often a dark place. Injustice, greed and cruelty run rampant. We know why: the world is fallen, so creation is warped. Things aren't the way they are supposed to be. People we love die too soon. Wars rage. Abuse happens behind closed doors. And if the abusers have powerful friends or good lawyers, they can get away with it . . . for years. It's heartbreaking, infuriating. It should cause us to grieve and show compassion for those wounded by a distorted world.

The cross sums up the darkness of the world: the powerful perversions of justice, abusing the innocent, fallen humanity killing their God.

A cross-shaped imagination sees the darkness of the world and responds with compassion and grieving.

More troubling still, we know that *we're* part of the problem (to borrow from both G. K. Chesterton *and* Taylor Swift!). It's not only that the world is a fallen mess; our hearts are too. We know what we're supposed to do, we strive to be better, but we fail (see Romans 7). The better angels of our nature go on holiday. Cutting words slip from our lips and hurt our children. A lustful glance here, a resentful, hateful grudge there. We know darkness intimately, for it lives in us.

The cross is the answer to the darkness that lies within. We are not as we should be. We are broken people with twisted desires. That darkness drove Jesus to the cross. We may not have been physically, historically in the crowd screaming for his blood, but our sin demanded his blood nonetheless.

A cross-shaped imagination recognizes the darkness within and responds with humility and repentance.

A cross-shaped imagination recognizes and tells the truth about the darkness within and without. A truly Christian imagination resists sentimental and comfortable images that edit out the darkness, that whitewash pain and distortion. We understand that darkness is always a part of the equation.

The empty-tomb-shaped imagination: living in the light

And yet . . .

In the Christian story, darkness doesn't have the final word, does it? The darkness and unjust bloodshed of Good Friday was followed by the dawn of Easter. Light has pierced the darkness, dispelled it and will ultimately destroy it. In a Christian imagination, we don't just see darkness. We see signs of life and hope all around us.

An empty-tomb-shaped imagination recognizes signs of hope in the world and in our souls.

We catch glimpses of those signs of life in gardens as shoots push up through the earth. Or in a museum when a picture takes our breath away. Or in a film when a child is saved, or when alienated lovers forgive and reunite. Or when a dysfunctional family is healed and those in it find that they really do love one another. Or when an addiction is healed. Every child born is a hint that hope remains, a hint that the grave isn't the final word.

The Christian faith has a certain momentum towards hope. We have placed our bets on the victory of the light. It may not be now and not currently complete, but it's coming. And it will be spectacular. For now, we see specks of spectacular, reminders of the comfort and joy to come. We recall that the world is not all dark, that the darkness will pass and be no more.

The power of the empty-tomb-shaped imagination lies in the surety of hope.

Embracing both in tension

A grounded Christian imagination is rooted in both the cross *and* the empty tomb, in the darkness *and* the light. The rightly ordered Christian imagination both grieves and cheers. It sees the world through tears of pain and tears of joy *simultaneously*. The Christian imagination is an odd and arresting thing . . . *if* it can keep these two realities in tension.

There is a place for praise choruses, but if that's all the world hears from Christian music, then it will ring false because life – for Christians *and* non-Christians – is not an unbroken chain of victories. There needs to be space for lament, for pain, frustration, grief and anger, even as we express our hope.

Think of our glasses metaphor. This is the strangest pair of prescription lenses ever. One is dark and warped, the other bright and clear. But only by looking through both do we get the full picture of reality from a Christian perspective.

It is that very oddness – that stance of hope against hope in a world where death seemingly reigns – that can speak volumes to the tired, the flagging, the walking wounded and the cynical.

Volume control: the balance between shouting and mumbling

The other issue that Christian creators must take into account is that of volume. How direct and declarative must the Christian creative voice be in a post-Christian world?

Too loud and it's an automatic turn-off. People feel preached at, yelled at and judged.

Too soft and people are confused about our motivations, what it is we're trying to say.

Neither of these is a true witness to the faith that shapes the Christian imagination.

As we shall see in chapter 7, art and entertainment are all about witness, expressing truth in love. But this is a delicate matter.

Christian art does not preach

Imagine you are trying to reach out to a non-Christian friend you have just made. You are trying to love him, to earn the right to be invited into his inner world. *How* you reach out to this person will make all the difference. You simply don't know where he has been hurt and how deep the wounds lie. You don't know who has hurt him – perhaps he's been hurt by Christians, brought up in the church but has decided he's had enough. You don't know his joys and sorrows, ups and downs, what makes him afraid or confident. You may know his *ultimate* need (Jesus), but you don't know his deepest *felt* need (the path that might just lead him to Jesus).

Therefore, you tread carefully, patiently. You do not unwrap the whole gospel package at once. You don't shout at him that Jesus loves him. You don't treat him as a target for Christian propaganda. You

give him what he can hear, gradually, sometimes indirectly, trusting that, in time, God will give him ears to hear.

It's the same with Christian art and entertainment in a post-Christian world. Artists must be sensitive to context if they wish to build bridges and plant oases. There is a place for preaching, but it's not *on* the bridge, not *in* the oasis. Here you must tread more carefully, be more indirect, suggestive and patient. Sometimes it means sitting in relative silence, listening and responding to pain and celebrating small joys and victories without bringing in the larger picture.

Because, as a matter of fact, you *don't know* the depth of damage carried by your audience. You don't know the layers of scars they carry, the walls of defence against the gospel that they have erected.

Rather than charging in, let your art open up a space for exploration. Let your audience members explore their own feelings, failings, hopes and dreams by the light of your imaginary world. Create imaginary spaces where the gospel makes sense, but is interwoven in the textures of the world that emerge as hints and whispered hope rather than shouted declarations. That is the essence of creating an oasis. Such works encourage repeat visits, conversations with other audience members, a slowly growing awareness rather than a demand that they take the plunge NOW.

Patience, restraint and subtlety are virtues of Christian creatives.

Christian art does not mumble

There is the danger, however, that we become so subtle, we end up saying precisely nothing in our art and entertainment. Think of your newly made non-Christian friend again. As you get to know him, you realize that you must also give something of yourself back to him. You don't just sit in utter silence for ever. Sometimes, especially when your friend is in pain, you do sit silently for a while.[1] But not for ever. Eventually, you reveal something of your own hopes and dreams and faults and failures. He gets to know what makes you tick.

And you dare not lie in this process or he's apt to get the wrong idea about you.

So it is with Christian art and entertainment. Sometimes, Christian creatives can become overly cautious about causing offence to the post-Christian world. So they hide any hint that the Christian faith might not be in complete agreement with the ways of the world. When that happens, it's like they don a disguise, become chameleons, blending in with the post-Christian world. Such art loses all Christian distinctiveness, like salt losing its savour.

This is a serious matter. Such a creative stance robs the audience of that which is ultimately most valuable to them: the hope of God's love and life with him. And, what's more, it puts the artists themselves at risk of being ashamed of Jesus. And that is a *deadly* serious matter. Jesus said in Mark 8:38, 'For whoever is ashamed of me and of my words in this adulterous and sinful generation, of him will the Son of Man also be ashamed when he comes in the glory of his Father with the holy angels.'

Mumbling in your art, trying to blend in, chameleon-like, may win the artist a bigger audience, but at the cost of losing your soul. God is merciful and our salvation is not in jeopardy from one errant work of art. But the Christian artist has a serious responsibility – don't shout and don't mumble.

Finding the resonance in between

There is a 'sweet spot' between being overly direct and being overly indirect. But it is tricky to find. The idea is to point to hope in a dark world without simply blurting out the message artlessly. Christian creators should aspire to crafting works that resonate with the hopes, dreams and anxieties of those living in a post-Christian world, moving imaginations into new territory for exploration.

Jesus' parables did this, though he worked in a pre-Christian rather than a post-Christian context. He began with things and people that his audience would have been familiar with – sheep,

coins, mustard seeds, robbers, vineyards, soil – and then wove meta-
phors and narratives that breathed new meaning into those very
things, subverting expectations in the process. You think the Levites
are the good guys and Samaritans are the bad guys (Luke 10:25–37)?
Think again! You think the runaway son is the only lost child in
the story (Luke 15:11–32)? Think again – the older son (a respect-
able religious person) is, in some ways, *more* lost than the one
who wasted the fortune! Starting with the known, Jesus takes his
hearers' imaginations into the unknown. He gives them something
to think and talk about. You could call this 'parabolic resonance' –
the way a parable can stir the imagination in this space in between
simply shouting out convictions and hiding them completely from
view.[2]

How does this translate into art and entertainment in today's
world? It will look, sound and feel different from medium to medium,
genre to genre, and even artist to artist. It's more about wisdom and
nuance than about hard-and-fast rules. Be on the lookout for
creatives who can do this well. Support them and learn from them.[3]

Conclusion: landing lights

The imagination shapes our perceptions of reality and can create new
fictional realities – all using the power of metaphor, of seeing-as.

The Christian imagination sees the world as a tension between the
darkness and the light. And if it wishes to gain a prolonged hearing
in the post-Christian world, it speaks with a voice that hovers
between outright proclamation and confused mumbling. It seeks
parabolic resonance.

These two axes – the tension between the darkness and the light
and the balance between shouting and mumbling – are not a
straitjacket. There are a million and one ways to create from the
Christian imagination, a billion and one ways to fly that airplane.
And not every work from a given artist needs to hit the 'sweet spot'

every time. There is room for varying emphases within an artist's collection of works. There is a range of ways to resonate.

This chapter is not meant to confine Christian creativity but give it some guiding lights and homing beacons so you can land it well.

Discussion questions

1 Christian artists and creatives can often struggle to find support among other Christians for imaginative works that are seen as not being explicitly evangelistic or Christian enough. How might you support artists who are aiming for Christian resonance rather than an explicit message?
2 What stories, songs or other artworks do you find most powerfully balance darkness and light, and realism about our broken world with goodness and hope?

Think of a creative piece that you were put off by because the artist was pushing a message or agenda in a way that was too obvious.

Getting started

- Why not start a book group, film night or listening party and invite both Christian and non-Christian friends together to discuss stories that have resonant questions and tensions? You might discuss how different stories create tensions between different viewpoints through the narrative – to what extent are these resolved or left open? What questions are you left with?

Bonus content: case study of a Christian imagination done well – half•alive

Let's explore a musical group that we believe expresses the Christian imagination in a way that resonates well in a post-Christian world.

half•alive is a trio consisting of lead singer/keyboardist Josh Taylor, drummer Brett Kramer and bassist J. Tyler Johnson. They have been around since 2016 and all their songs are up on YouTube.

Here is the exercise. Find the five songs listed below on YouTube. Taylor sometimes likes to distort his vocals, so to make things easier, search for the song titles together with the word 'lyrics'. Sometimes the music videos have subtitles.

- 'Creature', from the album *Now, Not Yet* (2019).
- 'What's wrong?', from *Now, Not Yet*.
- 'Conditions of a punk', from *Conditions of a Punk* (2022).
- 'High up', from *Conditions of a Punk*.
- 'Runaway', from *Conditions of a Punk*.

For each song, discuss the following questions.

1 What do you think the song is about? Specifically, what do you think is going on in the heart of the narrator of the song (the singer)?
2 How does the song express the tension between the darkness and the light? (It will be different for each song.)
3 How does the song find a balance between preaching and mumbling? (Again, this will be different for each song.)

Please notice how different these songs are in terms of how they handle the tension between light and dark. Some deal honestly with depression, confusion and deep disappointment, while others speak boldly about the hope that keeps the singer going.

Notice, too, how varied these songs are in their referencing of the Christian faith. One is fairly explicit, even naming Jesus Christ as sitting on the throne. Others don't mention God at all; some make an oblique reference. Taken together, though, it's hard to miss the Christian perspective and texture of recognizing brokenness mixed with hope.

Notes

1 And when you *do* start speaking again, you don't preach! That's something Job's friends found out a little too late.

2 Parabolic resonance is explored in more depth in Ted Turnau, *Oasis of Imagination: Engaging our world through a better creativity* (London: IVP, 2023), chapter 7.

3 Part 4 of Turnau, *Oasis of Imagination* explores six different works that do this well.

7

Art bears witness: stories about the purpose and power of creative works

Christians are called to be witnesses, to bear witness both to darkness and to light, to the realities of life's joys and challenges and to our hope in Christ.

The Christian imagination builds bridges and plants oases primarily through bearing witness. We connect with the world outside the church through bearing witness. A few stories will show you what we mean.

Bearing witness to that which we'd rather keep hidden

The gallery was empty and quiet. The walls exhibited Ruth's black-and-white archival photographic images from her body of work, 'The veil series'.

The golden, late-afternoon daylight flowed through the windows and everything was still. But then, I heard a middle-aged arts journalist asking if he could view the exhibition before the opening, which was to begin in an hour.

The gallery owner said yes and he walked into the gallery. I left him alone in the gallery. About 25 minutes later, the man came to the reception desk and complained about the exhibition. He did not like the photographic images and felt that the series had no direction or meaning. The man was agitated and upset and left the gallery in a hurry. I followed the man outside the gallery. He did not know it was my images on display and I did not tell him.

I followed him down the stairs and asked if he was OK. He replied that he was upset by the terrible images in the gallery. I asked him what disturbed him about the images. He shared that the images were too stark and direct and asked too much of the viewer. I asked him if he knew the exhibition's theme and he shared the description perfectly.

'The veil series' is a body of black-and-white photographic images that express the different 'veils' we experience while travelling along the path of life. Throughout life's journey, we encounter themes that may reveal our struggle to kneel, rise or stand. In these seasons we choose to embrace, reject, shield, conceal, shroud and grasp the realities of our veiled experience.

We sat on the step and talked for over an hour. I probed further.

'What did you mean, that the images asked too much of the viewer?'

He replied, 'The veils. The veils are like cracked mirrors.'
I asked, 'Are all the veils in the photographs hard to see?'
'Yes.'
'Why?'
He looked uncomfortable. 'Too close. Too much intrusion.
'What do the veils represent to you?'
He looked agitated, annoyed. 'I don't want to talk about it.
The veils are overwhelming.'

At this point, I felt that I needed to tell him who I was. 'Full disclosure: I am the photographer. I don't want you to feel uncomfortable. I don't care about your review of my work; I care how the images affected you and how you feel, positive or negative.'

His reply was curt. 'Well, I don't like your images. I gotta go.'

Before he left, I gave him my card. 'Please get in touch with me if you have any questions, or want to talk.'

A few weeks later, the journalist called me and we met for coffee.

He hesitated and then spoke. 'I kept thinking about your images, especially three images. Those images forced me to deal with a broken relationship with my partner. I mistreated my partner and years later, when my partner hurt me, I blamed her. The images made me look at my wrongdoing towards my partner. I didn't want to see my reflection in the veils. It was easier for me to lash out at the images and you than deal with my guilt.'

When we were leaving the café, the arts journalist said that he would deal with his mistakes, ask for forgiveness and deal with the veils in his life. But he *still* hated the images.

The arts journalist came to my gallery opening to 'experience art', but because he was actively present he was able to reflect on and respond to the art. And it caught him off-guard. He was not ready for the way that the images bore witness to the internal and external costs of his struggles, mistakes and sin. He did not want to experience that kind of bearing witness. He did not want to remain in the gallery

and yet, although he could have easily walked away, he did not. He endured the discomfort he was experiencing and allowed the images to invite him to see and confront the veils in his marriage and life.

Art invites us to look closely and thoughtfully explore the themes within and surrounding artistic expression. Art has the power to speak to the human condition and to strengthen and revolutionize thoughts and lives.

It has been stated many times that art has the capacity to ask the questions that need to be asked. If this statement is true, then where are the answers? Is it the artist's job to provide the answers? Should we provide the answers?

Not always, and not primarily through our art. Rather than rushing to give an answer, perhaps what's most important is that we sit in the silence with the weight of the question.

In that silence, art reflects what the artist observes or even bears witness to us about society and life.

'The veil series' began as a series of portraits. I asked my friend Sasha to sit for the first session. I had previsualized the series and was excited to shoot this first session. Sasha arrived and was visibly upset. She had just received very challenging news and needed time to process all the layers surrounding the news. She was experiencing a terrible season in her life. She was enduring tensions in her marriage, and her pastor and counsellor decided that she and her husband needed a trial separation. However, while preparing to separate from her husband, she discovered she was pregnant. We talked for over an hour, I listened and provided no answers. I told her we should reschedule the photo session. She insisted that we have the session, on one condition: that she not be fully seen in the photos. She did not want to reveal her emotions or her face. She wanted to be seen yet not seen. I tried different lighting options, but none of them seemed right. I grabbed a few scarves and some veil material and began experimenting with them, and the images worked well. For all my previsualization and planning of the photo shoot, what

resulted were powerful initial images – more powerful than I had planned – that bore witness to the tension of being seen and not seen.

I bore witness to the arts journalist's discomfort and anxiety. I sensed his pain. It made me sad that my body of work had produced this grief inside him, but I also knew that it only happened because Sasha experienced a terrible season in *her* life and she was courageous enough to show vulnerability and allow it to be captured on film. I put aside my feelings about his rejection of my images and sat and entered his silence, grief and regret.

Art has the capacity to move us in many ways. American novelist Caroline Gordon puts it this way: 'We do not judge great art. It judges us.'[1]

It takes courage to experience art, especially when it takes us on a journey to deeper discovery of our relationship with God, ourselves, our loved ones, our neighbours, our communities, our world and this path we call life.

Our art should bear witness, uncovering uncomfortable truths that we would rather keep hidden.

Bearing witness and abiding in grief: my surrogate father

What does 'bearing witness' mean? Bearing witness means acknowledging something that exists or is true. From a Christian perspective, it means we not only observe this life but we also see and accept what this life can bring. Moment by moment, we bear witness to what it means to live, survive, thrive, endure, fail, triumph and lament. We experience life, death, happiness, joy, sorrow, love, loss, relinquishment, embracing and rest. Our texts and social media are full of seeing, but also bearing witness. To deeply bear witness is to let go of our thoughts and what is happening in our lives to see, listen and act in a way that honours creation and helps a person or community feel seen, heard and cared for. It isn't so challenging to bear witness

to the joy and beautiful things. But bearing witness to complex issues, complicated relationships, suffering and death is hard. That requires our willingness to leave our stuff, our ego and our simplistic answers behind.

Our art should bear witness.

Art bears witness to what it means to be human in this world. Bearing witness can inspire artists and creatives to create and make art. Artists, like all humans, bear witness to life, communities, countries and the world.

Bearing witness through the lens of creativity produces something. It can be a powerful tool for bringing about transformation and restoration.

Bearing witness begins with seeing, with being open to others and the world around us. Leonardo da Vinci is often quoted as saying, 'There are three classes of people: those who see, those who see when they are shown and those who do not see.'[2]

There is so much beauty and pain and surprise in the world, if only we stop and take notice. If only we stop and see.

But seeing by itself does not complete the act of bearing witness.

In her blog, theatre and opera director Anne Bogart draws a distinction between observation and bearing witness. Observing is passive. It requires no commitment. Bearing witness requires us to 'develop a point of view in relation to what one has seen'. It requires us to act. As Bogart goes on to say:

Observation is not the same as witnessing, which in turn is not the same as bearing witness. Observation is the initial step and the platform from which one can become a witness. To bear witness requires the witness to also develop a point of view in relation to what one has seen.[3]

Bearing witness sometimes means existing in the not knowing. That means we walk faithfully alongside someone, not knowing what the

end will be. The end is important, but it is the moment to moment, when we bear witness in conscious action, that is crucial.

As believers in Christ, we trust God for the moment to moment. Bearing witness means trusting the Sovereign One who knows both our moments and the end. It is he who tells us to have faith in him and to trust him with our lives. We trust that God is working all things together for our good (Romans 8:28), moment by moment and to the very end of life in this world (Romans 8:31–39). It is in abiding with our Lord and keeping him at the centre of our minds that we can find the peace that passes all understanding (Philippians 4:7) – during others' storms or our very own. Bearing witness begins but does not end with simply seeing. It is in the committing ourselves to what we see, hear and feel that we must abide. Abiding is an act of commitment to another person.

What does it mean to abide? It means to last, persist, continue, wait for, remain behind and endure.

In some definitions the word 'abiding' means 'enduring' – for ever. God abides. He calls us to abide with and for others.

I experienced a profoundly beautiful bearing witness and abiding while I was grieving the death of my father. Its impact on me was so deep, I composed this poem, 'Remembrance'.

I entered the airport.
I saw him before he saw me.
My heart leaped.
What a gift just to see him.
His movements – his mannerisms.
I gasped oh so quietly.

Later, I was standing in an elevator.
He walked on.

"Hello," I said.

He looked at me and smiled.
With his warm, light brown eyes – the same shade I knew
 and loved.
He responded, "Hello, daughter."

Two words.
Warm in tone and enunciated in syncopations,
they went right through me.
Two words.
Tears fell from my eyes.

I told this beautiful African man how he reminded me
 of my own African American father, who had recently
 passed. He smiled, took my hands in his own, and said
to me, "It is an honour to bring forth the remembrance
 of your father. I will be
your father until we part."

My hands cradled by the hands of a stranger.
A stranger no more.

For the remainder of that day, I considered this encounter
 and contemplated
the meanings behind Time and Remembrance.

Time gives space for surrendering.
Time gives space for the courage and strength to relinquish.
Time gives space for loss.

My loss.
The loss of the first man who loved me and the first man
 I loved.
My loss.

The loss of being fully seen and known by one whose
 own blood
runs warm in my veins but no longer runs through
 his own.

In my music and photographic art, I protest, grieve,
 and honour the loss of my father.
For it was he who first identified me as an artist when
 I was six years old.

Time gifted me tears of lament and joy.

Time and loss can be revealed on our faces, our bodies,
 our souls,
and our spirits.

Time grants mirrored images to appear and remain.

Death ends life but not Remembrance.[4]

This surrogate father bore witness to my countenance of grief and he shared an active expression of awareness, empathy and grace. He was willing to walk alongside me, a stranger. He watched over me from the ride in the lift, during our international flight and until he secured my baggage and we said goodbye. He abided with me. It was not for ever, but it was the length of for ever in that spell of time. For that time, I was his daughter. For that time, he was my father. A for ever that I will never forget. He gave me the gift of his presence and profound words and his resemblance to and the mannerisms of my father brought me great joy. My sadness turned to joy because of his willingness to bear witness. His willingness to look and to see and to act. In return, I bore witness to the care of a once stranger but now my brother and friend.

Our art should bear witness by abiding with those in pain, bringing comfort in grief.

Bearing witness by breaching barriers: the Samaritan woman and a painting party

Consider Jesus' encounter with the Samaritan woman in John 4.

Jesus decides to go back to Galilee and travel straight through Samaria. He arrives, tired and thirsty, at a village called Sychar. Jesus sits down by a well – the same well that Jacob gave to his son, Joseph. While Jesus rests, he sends his disciples into town to buy food.

A Samaritan woman approaches to draw water from the well and Jesus asks her for a drink. The Samaritan woman, surprised at Jesus' request, reminds him that he is a Jew and she is a Samaritan woman. These categories of people simply did not mix. Jesus engages the woman further in a conversation, uncovering her own 'thirst'. The woman tries to deflect by bringing up a long-running religious debate about where God should be worshipped. Jesus cuts through her deflection by telling her that a new age has come – God isn't worried about location so much as he is about being worshipped 'in Spirit and in truth'. Jesus then completely knocks down her defences by showing her that he knows everything about her, even the parts of her story that she wishes would remain hidden. Astonished, the woman admits her own confusion, but says that she expects the Messiah will explain everything. Jesus then reveals that she's talking to him.

The disciples return and are surprised to find Jesus talking to the Samaritan woman, as they, too, are aware that this goes against what's considered socially appropriate. For her part, the woman leaves her water jar and rushes back to her village to tell the others (who had likely shunned her) about Jesus. She doesn't care about their treatment of her any more – they need to know. Meanwhile, the disciples urge Jesus to eat something. He declines and says that he's

got 'other food', and they should look around at the grain ripe for harvest. The disciples, as usual, miss Jesus' point completely.

The villagers, curious, hear what the Samaritan woman has to say about this Jesus. They invite Jesus to stay for two days. It's an unusual invitation – Samaritans showing hospitality to Jews. His acceptance was also unusual, for dwelling with Samaritans would, in most Jews' eyes, render a Jew impure. But Jesus takes them up on it and teaches them. As a result, many more villagers come to faith in this Messiah.

In the account of Jesus and the Samaritan woman there are many examples of bearing witness.

The disciples bore witness that Jesus did not take the route travelled by most devout Jews at the time – around Samaria to avoid the Samaritans. Instead, Jesus intentionally decided to go straight north, through Samaria on his way to Galilee. The direct route may have been three days shorter but saving time was not Jesus' goal. Jesus was intentional and was ready for the disciples, Samaritan woman and villagers to bear witness to the deep cultural tensions that festered throughout Palestine.

Consider: Jesus has borne witness to the Samaritan woman from before the beginning of time. He is her Creator. He knows her outer and innermost being. He bore witness not only as her Creator but also through his profound, active love as her Saviour.

When Jesus approaches the well, he does not see (nor does he care about) the barriers of ethnicity or gender that, according to the conventional wisdom of the time, should have kept him safe and separate from her. Instead, he sees a human, broken and needing living water.

Jesus asks her for a drink, knowing full well the religious and cultural barriers that made his request problematic. He does not care about social propriety. Instead, he bears witness to her humanity, refusing to let the hostility between the Judean and Samaritan Israelites – or the scandalous nature of a man talking with a woman – stop

him from engaging with her. She, in turn, answers defensively, fast-forwarding directly to the religious differences that should keep them apart. The Judean Israelites and Samaritan Israelites agreed that the Torah of Moses was to be obeyed, but they disagreed bitterly about *how* the Torah should be obeyed.

Jesus knows her, everything this woman has done in her life, but he asks a question anyway, a question that he already knows the answer to: 'Where's your husband? Go call him.' He then bears witness to his own glory: he lets her know that he knows about her past five husbands and the man she is currently living with but not married to. We do not know all the circumstances of her life's journey. We do know that, in those times, women could not initiate divorce. Her husbands could have died or perhaps they left her for not having children. Whatever the circumstances, Jesus continues to engage her in conversation, the longest conversation recorded in the Gospels. He does not spend time judging and reprimanding her. Rather, he sees through her defences to her discomfort and sadness. He witnesses to his own compassion and to her needy humanity. His main concern is her salvation – she needs to be led to and embrace the water of life.

The Samaritan woman, in turn, bears witness to Jesus. She sees and experiences, first, a wandering Jew, then a rabbi, then a prophet and, finally, the Messiah.

She knows that Jesus is asking for a drink from her water jar, but it soon becomes clear that, though Jesus is the tired, weary and thirsty one, it is *she* who is truly thirsty. Jesus bears witness to her thirst, her need. Jesus boldly tells the Samaritan woman that, 'we [Judeans] do know' and 'You Samaritans . . . do not know' what they both worship (John 4:22). Jesus witnesses to a future reconciliation that will unite Judeans and Samaritans. The worship of God in Spirit and truth will happen ultimately in the new Jerusalem.

The disciples arrive and see Jesus talking with the Samaritan woman, but they do not confront him about it. Jesus bears witness

to them about how they are to treat barriers and the people separated by those barriers. They ask about food and Jesus points and implores them to open their eyes and see the harvest right before them. He bears witness to them in their incomprehension.

After her eye-opening conversation with Jesus, the Samaritan woman bears witness to the Lord in her community. She cannot keep what has happened to herself. She leaves behind her water jug and runs to share the gospel with the rest of her village.

The people of her village then see Jesus for who he is and they bear witness to Jesus, the Messiah: 'We have heard for ourselves, and we know that this is indeed the Saviour of the world' (John 4:42). But they could do that only because Jesus bore witness to them of their value by setting aside the norms of their cultural purity laws and lodging with the Samaritans for two days. He and they bear witness that these people, made in God's image, are more important than human customs based on human traditions and prejudice.

This simple story is like a hall of mirrors of witness-bearing, light bouncing from Jesus to the woman to the disciples to the whole town, together creating a pattern that bears witness to the beauty of God's redemption in a broken world.

It is what imaginative works in Christian hands should do: bear witness by breaking down barriers.

I now want to tell you/brag about my (Ted's) daughter, Claire, and what art can do in Christian hands.

Claire has a creative streak that was apparent from a very young age. She could never stop drawing, painting, singing, storytelling, living and acting high drama.

Her teen years, though, were ones of mighty struggle. She suffered a trauma perpetrated by a trusted friend that sent her reeling, out of control. She struggled with self-harm. She struggled with a nasty eating disorder that sent her to hospital. She struggled with mental health, anxiety, depression, borderline personality disorder. She also walked away from the Lord and for years we couldn't broach the

subject without her getting upset. It was a dark and rough time, and lasted for years.

One desire crystallized through those struggles. When Claire was 15 and confined to a psychiatric ward during her battle with anorexia, art therapy was part of her treatment. She loved it and made a vow that, when she got better, she would use her art to help others.

Somehow, she managed to graduate from the Anglo-American University (where I teach) with a degree in Visual Arts (because she's whip-smart and full of determination).

God intervened in a rather peculiar way in her life (that's a story for another time). It scared her. It also caught her then fiancé's attention (they are now married). After that experience, they both wanted to be on Team Jesus. Claire volunteered to help take care of her fiancé's grandmother, an elderly Catholic woman with advanced dementia. She'd spend the day with her, doing simple art projects, gluing cut-out pictures from a magazine on to paper to make a collage. This woman who had no memory cemented in Claire's mind the possibility of living in God's love. She was so gentle, so sweet, so thankful to God for what she had. Her bearing witness imprinted itself on Claire's heart.

Claire gained work experience at a place that hosted 'painting parties', serving mimosas to bored housewives while they painted a model painting, led through the process by an art hostess. Claire was a natural, but found it taxing. Her bad back stopped her from keeping that job for long.

But she used those skills in her next job, working as an arts mentor at a centre that served those with physical and mental disabilities. With her newly rediscovered faith, she wasn't put off as others might be by the disabilities or racial differences – she was drawn to these humans who needed help. She told us all about how these people flourished when being creative.

She prayed for months for God to give her a chance to use her art to bring beauty and light into the lives of people who needed them,

and she felt especially called to help the homeless population in her area. She got involved with a local church that had links with a homeless shelter.[5] She asked at the church if they would be willing to support a project that she had in mind: regular painting parties at the shelter. The church agreed enthusiastically.

She went, discovered the paints the church had ordered were low-quality ones. No matter – she used her own. She and her (now) husband set up painting stations. She had prepared a model painting, but told them, 'This isn't a painting class. You just go explore. If you want to follow my example, fine. If you don't, spread your creative wings. You all are artists.' And then they started to paint.

She heard comments from the residents at the shelter. 'Nobody's arguing. Everybody is laughing and having a great time.' A man who spoke broken English told Claire that it was the first time he'd smiled in two years. She didn't go to evangelize, but she did share with one resident that she was on 'Team Jesus'. She did two sessions for a total of eight hours. She was exhausted.

Later, in the car, alone with her husband, she wept for pure joy. *This* is what she'd been dreaming of doing since she was 15 years old: helping others with her art, leading them into God's beauty. She accepted it as a gift.

Claire has painted many pictures, often with Christian symbolism. But none of those is her greatest work of art. That event, that project, has become her greatest work of art. It bears witness in so many ways. She didn't see barriers. She saw broken humans needing help. Then she acted. She breached those barriers, the lines that too often separate human beings. She committed herself to entering into their pain and offering what she was able to offer – creativity, a chance to image God, the Creator. And for those hours, they blossomed, humanity healed, dignity was restored.

It wasn't, strictly speaking, directly evangelistic. She didn't give a sermonette. But she went there to shine the light of Jesus on these forgotten people. In its own way, her painting party mirrored Jesus'

conversation with the Samaritan woman: seeing humanity instead of barriers and actively committing, entering the world of the broken, offering peace and healing. In time, relationships will form and Claire will be able to lead some to living water (trust me, my daughter is *not* shy about sharing her faith). But the context for that is a life-giving oasis, her art.[6]

Bearing witness is seeing – seeing the people around us, seeing the changes that God might be leading us into. To see, we must adopt a posture of wanting to see, wanting to act on what that can bring into our lives.

Our art should bear witness, enter into brokenness and offer healing, even (especially) when that means breaching barriers that keep us apart.

Our art should reflect the way Jesus bore witness. Bearing witness means sacrificing something of ourselves, being open to pain and beauty. Bearing witness means abiding in love for a dark and dying world, praying for and sharing the light.

Discussion questions

1 Has an art piece (for instance, a song, painting, photograph, film or TV programme, novel or video game) ever confronted you with a hidden truth about yourself?

2 What does it mean to 'abide'? What value does abiding have for your relationships?

3 Has a piece of art ever helped you to abide where it's difficult to be?

4 How can art (or even the activity of making art) serve as a passport that allows you to overcome barriers that normally separate people? How does this in itself bear witness to the truth of the gospel?

Getting started

• Consider starting an arts group in your church committed to breaching social barriers. Think about how, like Claire's

group, you can bring together different types of people and encourage them to explore their own creativity.

- Go into a community space, such as a park or town square or coffee shop and observe attentively what goes on there for a while. Be a witness. Then have a go at creating something that describes or responds to what you saw there, maybe a sketch, poem or written reflection.

Notes

1 Quoted by Madeleine L'Engle in *Walking on Water: Reflections on faith and art* (Wheaton, IL: Harold Shaw, 1980), p. 46.

2 This quote is popularly mistakenly attributed to da Vinci. For more detail on who *did* say it (or something like it), see quotes from various editions of Niccolò Machiavelli's *The Prince*, chapter XXII, and that from Dimitri Merejkowski's *The Romance of Leonardo da Vinci*, Book XII, chapter IV, in a post by Sue Brewton, 'No, Leonardo da Vinci did not write that either', *Sue Brewton's Blog* (31 July 2016), <https://suebrewton.com/tag/there-are-three-classes-of-people-those-who-see-those-who-see-when-they-are-shown-those-who-do-not-see>, accessed March 2023.

3 Anne Bogart, 'Bearing witness', *SITI* (18 February 2016), <https://siti.org/bearing-witness>, accessed March 2023.

4 This poem will be published in Kyla Marshell (ed.), *M³ Anthology of Writings Vol. 4*, M³ (Mutual Mentorship for Musicians; 2023).

5 Homeless shelters in the USA are different from homeless hostels and night shelters in the UK. The services they offer vary greatly. In this case, the shelter offers medium-term housing, help with finding a job, drug addiction treatment, as well as assistance with locating more permanent accommodation. For residents at the shelter, it is their home for the time being.

6 As I am writing this, Claire is preparing a grant proposal, seeking funds for an exhibition of the shelter residents' art for November 2023. The exhibition is entitled 'Human voices'. When she asked

the residents if they approved of the title, one female resident said, 'Yeah, I like it, because the art speaks for itself.' Claire's oasis is gaining momentum.

8

Bearing witness:
how to support your
local creatives

Artists in our community bear witness, enriching our
imaginations with their creativity. We, in turn, should bear
witness to them by supporting and nurturing the artists
and creatives among us.

To live as a Christian is to bear witness to what it means to be human.
Every day you wake up and witness the beauty of creation. Every
day, you bear witness to the tragic twistedness of humanity as you
hear about a hundred injustices on the radio, TV and on the Internet.

You witness acts of kindness between people. You witness the tedium of a repetitive job and homework and cleaning the kitchen. Life itself means bearing witness. Living comes with the responsibility to bear witness before God and others; not simply to consume or experience, but also to participate.

In many ways, we do not have a choice as to whether or not we bear witness to life's experiences or creativity. However, we do have a choice as to whether or not we will be actively present in bearing witness to life and its creative expressions. Witnessing the beauty, joy and love this life offers is rewarding. But it takes enormous strength to bear witness to the challenging and complex experiences on this path we call life. In some ways, bearing witness is an act of remembrance, naming the human experiences and their impacts on our lives, communities and world. To bear witness is to testify to what we have seen, heard, felt and experienced. Bearing witness is the gift of entering into another person's space and encountering their humanity with respect and dignity. Artists relinquish the temptation to problem-solve and actively listen instead. They witness what they hear in song, picture, words and film.

There are, of course, different ways of bearing witness. As we saw in chapter 7, artists bear witness through their creative work.

How do those of us who are not artists bear witness? We do so through carefully listening to and watching the artists' creative testimonies – their artworks – and then responding in thanks. For Christians, bearing witness should always be accompanied by gratitude for the gifts God has given (1 Thessalonians 5:18).

Creatives and imaginative creativity in the church are surely gifts. Bear witness to them.

Gratitude for creative gifts is right and good. But can we speak the truth in love when confronting messages coming from some artistic works even when we disagree with them? They were made by humans who are made in God's image and have made themselves vulnerable. We can have a positive influence on the wider creative community

by engaging with creative works even when we do not believe that they glorify God. Being active participants and supporters in the creative community enables us to build relationships with respect, trust and support. Engaging the creative community allows us to influence the presentation of truthful, authentic and inspiring art. This, too, is a way of bearing witness.

Authentic witness is always rooted in love. We Christians are marked by this: they shall know we are Christians by our love for one another (John 13:35). You may not always understand those called to the creative professions, but they are your Christian brothers and sisters. At its most basic, this chapter aims to provide you with practical steps that show how to love those who bear witness creatively in the arts and in entertainment.

The act of bearing witness to creatives, the creative process and creativity are beautiful gifts, both for those who create and those who receive that creativity. To see, listen to and experience creativity is to bear witness ourselves, together with the witness of others and the surrounding world, in love. This is where oases start. Supporting and serving creatives as they practise their art bears witness to the transformative power of the imagination in planting oases.

Creatives make a unique and vital artistic contribution to their communities. Of course, we all have our favourite visual artists, musicians, poets, dancers and writers, most of whom are nationally recognized and celebrated. But many creatives desire to share their artistic work on a smaller scale, in their grounded and rooted communities. In this chapter, we will focus on these local artists.

Besides demonstrating love, engaging with creative works and people benefits those most who give of themselves. Like a boomerang, the love you give to artists comes back to you in all sorts of unexpected ways. When people engage with art, it increases their cognitive abilities and produces more significant well-being, peace, flourishing, beauty – in a word, shalom. Engaging in art encourages the community and is also a wonderful form of personal care, refreshing the spirit.

Here are ten ways in which you can support the creatives in your midst and how such acts of kindness have had an impact on me (Ruth) as an artist.

Show up: the gift of presence

'I want to support you and I want you to see a friendly face in the audience.' These words were spoken to me by my friend Georgia. Over the past seven years, she has attended most of my lectures, workshops and music performances. Her words and physical presence are beautiful gifts to me.

I was invited to be a panellist for an online presentation. The topic was controversial. The day of the presentation was hectic and stressful and I felt drained. I logged on to Zoom before the event began to meet with the other panellists before it started. As I heard the other panellists interrupting one another and speaking pointed words, I knew that this would be a heated discussion.

The event began, and while the moderator made the usual introductory remarks, I was praying for wisdom. I wanted to speak the truth in love without being defensive or contentious and offer creative solutions to the concerns and issues facing some of our communities.

I looked at the attendees and saw my friend Georgia. She was smiling. Simply seeing her made me relax and feel at ease.

The panel was combative and difficult to navigate, but Georgia was a source of encouragement, by her presence and the messages she sent to me.

One of the easiest, but also one of the most deeply significant, ways to support your local creatives is . . . to be a Georgia. You can give the gift of your physical presence. You can love the artist just by showing up. You can acknowledge and appreciate the work of creatives by being physically present at exhibitions, concerts and events at local churches, performance venues and other artistic spaces. Your presence at these events represents community support and can unite

the community around and through creativity. A church community's presence at these events encourages the artist more than you know. It can even lead to very tangible support by increasing an artist's exposure, bringing further opportunities for the creatives to share more of their artistic work in the future outside the community. Being physically present in the space where creativity is offered and shared helps to cement relationships and cultivate community identity. Even if circumstances keep you from being present physically, many events are also offered virtually. You can extend your presence by attending creative events as part of an online art community.

This kind of support also inspires future artists in your community to create and share their art.

Buy in: purchasing art, booking local musicians

I remember standing in the gallery at the opening reception for my new body of photographic work, 'The veil series', wondering how people would react to my images. The gallery is small but respected, in Philadelphia's most culturally diverse area.

People seemed to be enjoying themselves. They were consuming the delicious refreshments, looking at the photographs and conversing with one another.

Then, the gallery owner came over and pointed to one of my photographs across the room. At first, I did not understand why she was pointing at it. Then, she came near, grabbed my hand and walked me to the photograph. Finally, I saw the 'red dot', which means someone has purchased the photograph. I was delighted and grateful. Throughout the rest of the evening, the guests noticed the sold piece and the gallery owner told me that it encouraged two further sales.

I found out later that the first purchaser of one of my photographs was a friend of mine and a member of a church that I have attended and sung at for three decades. My friend and his wife invited me to their beautiful home to see the photograph hanging in their living

room. I was grateful and joyful because they loved the photograph and supported my art.

After that, other people in our church community started attending my exhibitions and engaging with my photography; a few have purchased my photographs. In buying that first photograph, my friend supported both the gallery and me, enabling the creativity to continue.

You can support and encourage creatives by helping them to earn a living. They need to keep a roof over their heads, pay the bills and put food on the table, just like everyone else. We do not always think about shopping locally, but buying the work of local creatives, booking local musicians and so on funds their work and contributes to the economy and overall health of the community and relationships in it. You receive a unique piece of art and hear music connected to your region and community, and they needn't be a financial burden. Choose something within your budget and it will bring you joy in the purchasing of it.

Supporting local arts in this way creates social connections between you, the creatives and beyond. As there are now many convenient buying options online, such as gift certificates, you can help to introduce and connect other people from the community to the local creatives you find, helping them further. For example, my cousin once complimented me on an ornately carved wooden necklace I bought from a local jeweller, so I gave her a gift certificate. She loved the jewellery she bought with it so much, she ended up buying some gift certificates herself and other pieces of jewellery for her friends. One of those friends got a beaded amber bracelet from her as a gift and liked it so much, she recommended the jeweller to a celebrity. Because of that connection, the celebrity placed several orders with the jeweller to make custom pieces, which led to the jeweller receiving nationwide recognition for her work. Recently, she gave me a beautiful, swirling bronze necklace set against black beads as a thank-you gift. Acts of support and kindness to artists tend to take on their own momentum, and sometimes they return to the sender as gifts.

Become royalty: being a patron

A patron of the arts is a person or guild or organization that gives financial support to an artist. In the blog *Artwork Archives*, there is a good description of patronage:

> Historically, people in positions of power like kings and queens funded all types of visual artists to outfit their homes, cities, and important buildings like churches and town halls. If you were an artist and had a powerful patron, your financial security was all but guaranteed. In the Italian Renaissance, patrons either took on artists and commissioned them work-by-work, or they fully took them into their estates and provided them with housing while the artist was 'on-call' for all art needs. Depending on the scale of a project, an artist could be funded by patrons for years.[1]

For those who want to support creatives more substantially than by simply buying their work or tickets to their performances, do consider this time-honoured way to encourage creative works. A modern-day patron can develop a more profound and long-term relationship with an artist or artists, and even be part of bringing forth the creative offering. In addition, patronage provides financial stability and helps an artist's profile and creative work become more visible. For example, suppose you are interested in experiencing an artistic offering that reflects ideas or themes you cherish. You could commission a local creative to paint a picture, compose a song or write a poem. You would also contribute to their CV or online profile, adding to their artistic credibility (which could turn into future work for the artist).

You could be a patron who provides for a specific need. For example, an artist friend of mine was invited to share her work in an international exhibition. Unfortunately, she did not have enough

money to pay for the plane tickets needed for her to attend the reception for the opening. A friend of the artist learned of this problem and asked one of his friends who has surplus mileage reward points if he would donate the necessary miles and accommodation points. He was happy to. Indeed, he continues to donate miles to the artist so she can travel when needed for exhibitions, workshops, conferences and artist retreats. Another artist friend has a patron who covers the insurance for her early music instruments collection.

Unlike the kings and queens of old, modern patrons need not be that wealthy. Patronage websites, now known as 'crowdfunding', such as Patreon, Kickstarter and Indiegogo, can be found on the Internet for those who can only contribute modest amounts. Whatever your income, being a patron of the arts and other creatives is within reach. In these ways, you can be instrumental in bringing unique art and other creativity into the world and help to give local creatives financial support.

Patrons don't have to be individuals. A group of friends can pool resources to support an artist or performer. Church communities can make room in their budgets to support artists too. After all, they are cultural missionaries, just not working abroad. A growing number of churches have 'artist-in-residence' programmes that support creatives for a year or more. Such arrangements are patronage brought into the modern world.

Get loud: spreading the word, networking

As an independent artist who creates music and photography – I co-founded my record label and I do not have a commercial gallery that represents me – I rely heavily on community support.

When I organized a couple of concerts to mark the release of my first album, I did not have the money to advertise in newspapers. Instead, I made posters, flyers and postcards and put them in coffee shops, museums, galleries, performance venues, libraries and so on.

I also created email lists and made phone calls to friends and family to invite them to the concerts.

Two local radio stations took notice and announced the concert dates for free and requested interviews with me. I encouraged everyone to share the information about the concerts. Several of my friends committed to bringing groups of people to one of the concerts. They made the evening a wonderful outing by having dinner and drinks before or after the concert.

The two concerts sold out. Before I began singing, I looked at the audience and my heart was filled with joy at the fantastic support of my community.

Social media has made promoting a concert or exhibition much easier than it used to be. A simple like, share or reshare makes a difference. A concert in my home town was successful because several friends shared the concert information. Their kind gesture of spreading the word made such a difference.

You can do so much to support local creatives by getting loud and enthusiastic about them. Word of mouth is key, so spread the word in your community! Social media has its toxic side, but it is also a wonderfully effective tool for sharing your excitement about local creatives and their artistic offerings.

When used in a healthy, productive and balanced way, social platforms such as Facebook, Instagram, Pinterest, Twitter and TikTok can help to give local creatives exposure. For creatives just starting out, exposure is everything. Follow some local creatives on these platforms. That can have a positive impact on their profiles as well as on the profile of your community (it reflects your community's 'imaginative inventory', which sorts of artists nourish you). Share their work within your social media community. Like, share, subscribe and comment on their posts, on their creativity, techniques and how their artistic offerings have had an impact on you. These simple actions deeply encourage local creatives and have a positive effect on their online visibility.

Join up: becoming a member or gifting a membership

Consider becoming a member of an institution that supports artists, such as a museum, art gallery, concert hall or theatre. If you're already a member, you could gift a membership subscription to a friend or family member. This is a really helpful way to open a doorway for them into the world of the arts. And it helps artists, as your friends and family come to understand their work better.

You can also give direct help to artists by gifting them a membership subscription that they perhaps couldn't otherwise afford. A friend gave me membership of a historical society. Since much of my music is inspired by historical documents, this society's rare-document archive was critical to my composing. By giving me access to it, this friend helped me to make music. Likewise, visual artists benefit from being members of museums and art galleries where they can see the great works of the past close up. Such works inspire the works of the future.

Membership subscriptions also build a robust relationship between creatives, the community and arts organizations. Volunteering time and donating money to local community art groups, galleries, performance venues and organizations, societies and art charities can support both creatives and creative spaces in a way that has a great impact. It can also help provide tourism for your community through the lens of the arts.

Give shelter: donating time and space

I was once commissioned to create a body of musical works over a short period of time. I was stressed out.

A friend asked me how she could pray for me. I told her that I needed quality time and a quiet space to finish composing music for

the commission. She then invited me to stay at her house and even provided food. That week was an amazing gift. Time stood still. I could compose, sleep, take walks on the beach any time I desired. I was able to go into isolation and focus on the project. It made a huge difference, creating in a new space with no responsibilities. I completed the commission and I remain deeply grateful for her gift of time and space.

Offering a room in your home while you are away provides this time and space for an artist. It is a beautiful way to support creatives, who often don't have quiet spaces of their own.

Creativity doesn't just happen, especially not in a world full of distractions and obligations. Artists need a place and time away from it all to concentrate. Donating temporary housing provides artists with space to break away from the pressures of daily life, to renew, refresh, restore and unwind.

An artist retreat can provide a quiet space to rest and be still. It provides inspiration for a spiritual time of reflection. It can inspire new ideas, new creative work and provide the necessary time to complete an artistic project.

There are ways in which church communities as well as individuals can get involved. Churches with extra space might consider, for example, letting a creative use a spare room as a studio. Even better, an artist-in-residence could be taken on as a member of the church's staff. Both options allow a creative time to sharpen the skills needed to plant oases.

Get to work: volunteering

There's a little theatre in Philadelphia that puts on quality performances with only a shoestring budget. I love the dedication and talent on display. But the theatre cannot afford ushers. I thought that was a shame, so I volunteered to usher for the theatre once a month. Members of the audience who recognized me were surprised. 'What's

a jazz singer doing ushering in a theatre?' 'Because I love them and want to encourage them', I said.

Volunteering your time, skills and resources to serve at local community art groups, galleries, performance venues and organizations is one of the most underappreciated yet powerful ways to make a difference in your community. By volunteering, you are supporting creatives and helping to maintain creative spaces by filling in the gaps where assistance is needed. Whether ushering at a theatre, setting up food for a reception at an art gallery, folding programmes or working in the office of an arts organization, you are building relationships and can become a member of the team that works together to meet the goals and fulfil the vision of the creative institutions. For those who are retired and miss the feeling of being useful that they got from their jobs, volunteering can provide a sense of purpose. You are making a difference by sharing in the creative side of your community.

You can also volunteer your time, skills and resources directly to artists. For example, you can offer childcare, transport, meals, all sorts of other helpful things, so that they can set time aside for creating. From the artists' perspective, such help is just as important and loving as giving monetary support or providing a space in which to create.

Learn a thing or two: going on a course or participating in a workshop

A lot of people don't think that photography is art. 'You just point and shoot, right?'

I taught a 12-week photography course and one of my students was a young woman, 17 years old. She had taken many photos but didn't like what she saw. I worked with her and introduced her to the concept of photographic composition. It's *not* just pointing and shooting. It's letting your eye find patterns and arrangements that resonate with a deeper meaning.

We worked during and after classes and, gradually, she started to understand how hard photographers work. She also developed skills and confidence in her own artistic abilities.

She developed an appreciation for the art, the process. When that happens, it means the world to artists.

Many people, however, simply don't understand artists and how art works. One of the best ways to overcome that information gap is to sign up for a course or attend a workshop offered by artists. They not only enable students to get a basic grasp of technique, but they will establish a relationship with the artist as well. Learning more about the artists and understanding their creative processes, techniques, talents and production methods is educational and can be inspiring too. Plus, it's a lot of fun to create with a group, be a student and discover your own artistic talents and those of other members of the group.

Warm hearts: saying some encouraging words

I was sitting in a coffee shop trying to write the lyrics for a song that I had composed. It was not going well and I was discouraged. It was my third attempt at writing lyrics for this song. There was time pressure because I wanted to share the song at my next concert.

For the most part, my lyric writing flows well, so I was beginning to wonder whether I should continue trying or return to it in a few weeks. As I was contemplating these options, a young man entered the coffee shop and smiled at me. I returned the smile and he came over to my table. He asked if he could share something with me. I agreed and he began sharing my composition, 'In a whisper'.

The song is about God's whisper and was inspired by Elijah's experience after he was victorious against the prophets of Baal. Jezebel sought to kill Elijah, so he fled to the hills, travelling to a cave. The angel of the Lord instructed Elijah to go out and stand on the

mountain before the Lord, as the Lord was going to pass by. The Bible tells us:

> Then a great and powerful wind tore the mountains apart and shattered the rocks before the LORD, but the LORD was not in the wind. After the wind there was an earthquake, but the LORD was not in the earthquake. After the earthquake came a fire, but the LORD was not in the fire. And after the fire came a gentle whisper. When Elijah heard it, he pulled his cloak over his face and went out and stood at the mouth of the cave.
> (1 Kings 19:11–13, NIV)

The young man shared how the song reminded him that sometimes he needs to be still and silent and wait for the still, quiet voice of the Lord. The song also reminded him that he could pray in a whisper, his prayers did not have to be loud or bombastic. He could whisper a prayer.

I thanked the young man for listening to the song and sharing his thoughts with me. He smiled and ordered his coffee and, when he left, he waved and smiled. I would love to say that, at that moment, my lyric writing began to flow. It did not. But the encounter with the young man encouraged me and prompted me to review all my lyrics. A few days later, the lyrics did flow and I wrote my song 'Who among us'.

When we offer words or gifts of encouragement to creatives, we share love and hope that can spur them on. It's a way of saying, 'Thank you.' Receiving gratitude – knowing that their work made a difference to someone – means so much! You can send a note or token of thanks to a creative for bringing art and beauty into the community. A care package or gift voucher for a favourite café can lift a creative's spirits. Creating is hard and sometimes it's a grind. Creatives can experience discouragement, lose hope and get depressed, just like anyone else. A simple gesture of a text or call can bring about

inspiration. The creative feels seen and cared for, knowing that someone is thinking of them on their journey during the art-making process. The gift of encouragement helps creatives literally to 'take heart' (that's what 'encourage' means), so they can continue their journey towards their artistic goals.

The creative process can be terribly isolating – it's you and your thoughts and your medium or instrument. When we encourage creatives, we are helping them to know they are *not* alone in creating. Encouragement helps creatives to move from uncertainty to determination, from determination to action, and from action to achievement.

Again, churches and especially pastors, have a role to play here. During worship, in the congregational prayer, for example, make it a habit to pray for the artists and creatives in your congregation and community. If you know of none, pray for God to raise up one or more. Hearing prayers offered on their behalf will help the rest of the church to understand that creatives are precious brothers and sisters who serve as ambassadors for Christ through their creative works.

Open up: hosting an art event at home or in your church

Hosting an art event is a beautiful way to promote creatives in your community. It can be an inspiring, educational and exciting evening for the artists and the guests. It gives artists the space to share about their art, making process and life of creativity. Artists and audiences can have conversations in which they learn from one another, ask questions, raise issues big and small and float possible solutions. Hosting artists at home or in your church by holding an art event is a beautiful way to give back to the community while raising the artists' profiles by making them *part* of the community. The artists and members of the community can interact and experience a free exchange of ideas surrounding the themes presented by the artists or hosts.

I remember the first art event that I hosted. It took place in our living room. It was a laid-back and comfortable evening, with 14 guests. The guests mingled and consumed light hors d'oeuvres beforehand and, after a while, the musicians – two sisters, a violinist and a cellist – began playing. After they shared their music, the artists and guests conversed and asked questions.

The artists had the opportunity to share about their artistic process, projects they were working on, their struggles and why they were drawn to music. They sold their recordings and there was a bowl for our guests to give monetary donations if they desired.

The artists communicated their gratitude to me for creating a space in which they could play their music to new people. The guests were glad to be introduced to the two artists and three of the guests went on to became supporters of their music.

The whole church can get involved in hosting such an event as a church. Church sanctuaries can become concert venues for Christian musicians or spoken-word artists. A hallway can provide an informal gallery space that helps an artist to get noticed, with a 'gallery opening', complete with snacks, drinks and a local musician or group providing music to announce the exhibition. There are many other ways in which church communities can encourage and support local artists.

Conclusion: giving something back to creatives

Creatives can add so much to the life of Christian communities and to each of us individually. But they cannot do it alone – they need the support, encouragement and kindness of their brothers and sisters in Christ to help them to develop and have the greatest impact.

The church needs to be intentional in how it relates to artists, it needs to give them room to grow, space to create, funds to make ends meet, so that they can build bridges into the wider community.

We hope that the ways in which you can support artists and other creatives that we have described here have given you some ideas for things to try. Good ideas.

Discussion questions

As this whole chapter has consisted of practical guidance, we have just two questions here and no 'Getting started' section this time.

1 Which one (or more) of the ideas in this chapter are you willing to pursue to love and support the Christian creatives around you?
2 How can you get more people in your church on board with your ideas (by finding spaces for an exhibition, supporting a local artist as a cultural missionary and so on)?

Notes

1 'The role of the art patron in 2020 . . . and how to find them', *Artwork Archive* (25 February 2020), <www.artworkarchive.com/blog/the-role-of-the-art-patron-in-2020-and-how-to-find-them>, accessed March 2023.

9

Words of encouragement to artists . . . and the rest of us

Christian artists need the church, and the Christian community needs artists. Christians of the world, unite!

Ruth's words of encouragement to artists and creatives

The First and Greatest Artist, who created out of nothing, looked at everything he created and declared it good! That is the same One who gave us the gift of creativity. We are his image bearers and our purpose is to reflect his artistry and bring glory and honour to him. In our lives and art, we should reflect the honour, dignity and value of God's purpose for humankind. Christian novelist

Madeleine L'Engle stated in her book, *Walking on Water: Reflections on faith and art*, that: 'The discipline of creation, be it to paint, compose, write, is an effort toward wholeness.'[1] As creatives and artists, we have the unique privilege to connect to people and have our art move them. Our works, created by our hands, can lead to transcendence and transformation. When that happens, it is the message that is centred, for the artist is merely the messenger. God can express something beautiful through us. What a privilege!

But caution: Christian artists must avoid two pitfalls as we make our art. There are others but watch out for these two especially. The first is idolizing our art and artmaking. There is one Creator; we must never elevate the mysterious and unique art creation process above God. There is no place for the idolatry of art. We point to the Creator, not the creation. What is our purpose as artists? To glorify God and enjoy him for ever (1 Corinthians 10:31).[2] Abiding with our Creator and Saviour in his word and through prayer keeps our focus and intent clear and on point.

The second pitfall, to avoid like the plague, is the secular–sacred divide. Nothing is so dark that the Light of the world cannot redeem. There is no wall, no separation between the secular and sacred. God cares about our every thought, word, deed and action in the artistic and every other area of our lives. As Charles Spurgeon, the 'Prince of Preachers', once said:

> To a man who lives unto God, nothing is secular, everything is sacred. He puts on his workday garment and it is a vestment to him. He sits down to his meal and it is a sacrament. He goes forth to his labour, and therein exercises the office of the priesthood. His breath is incense and his life a sacrifice. He sleeps on the bosom of God, and lives and moves in the divine presence. To draw a hard and fast line and say, 'This is sacred and this is secular', is to my mind, diametrically opposed to the teaching of Christ and the spirit of the gospel. The Lord hath cleansed

your houses, he has cleansed your bed chambers, your tables . . .
He has made the common pots and pans of your kitchens to be
as the bowls before the altar – if you know what you are and
live according to your high calling. You housemaids, you cooks,
you nurses, you ploughmen, you housewives, you traders, you
sailors, your labour is holy if you serve the Lord Christ in it, by
living unto Him as you ought to live. The sacred has absorbed
the secular.[3]

Don't be discouraged amid tensions, struggles, failures and obstacles.
To create is to protest against the darkness and evil in our hearts and
this world. Being present and willing, we witness the fullness of this
life's path: the good, the bad, the pain and the joy. We are affected by
the triumphs and trials in our lives and the lives of our families,
friends, neighbours, communities, nation and world. But beauty
remains because the *source* of beauty, Jesus, is the same yesterday,
today and tomorrow. With this beautiful fact, we can continue to
create about what it means to be human in this world, along with the
hope of eternity.

There are so many things that can cause discouragement in
creating art. There needs to be more inspiration, understanding,
money, support, supplies, time and space to create and share art. The
struggle is real. There have been many artists who became depressed
and gave up creating. Sometimes there is the tension of making our
art a successful business while creating art that matters the most to
us – without compromise. I experience this struggle. I continually
lay this struggle at the feet of the One whose promises are yes, yes
and amen. The One who said his creation is good is the same One
working it out together with us for our good. Our job is to trust him.
There may be dry seasons when we must blindly trust God for the
provision and the art. God has proven himself over and over and over
again. I believe in the garden of our artmaking; we can be fruitful
and multiply to give God the glory that he so richly deserves. And if

God chooses not to answer our prayers as we hoped, we still have to trust that he is working it out for our good. We know the end of the story; our job is to trust the journey. We can embrace Christ and his cross and, as my kinfolk say, 'follow his will and his way'.

Ted's words of encouragement to the rest of us

Before I speak my piece, I would like to ask the artists and creatives to stop reading. Now. Even if you're an arts student, seriously, go do something else for a while. Go ... paint a tree or compose a sonnet or something. As Ruth said, 'Go do something that glorifies the King.' While you're doing that, the rest of us need to discuss something with you out of the room.

Waits while artists and creative types exit

Have they gone? OK, now that we're alone, we can talk honestly about creative types.

I want to encourage those of you who, like me, do not earn your living by working in the fields of arts or entertainment. Let me start by saying something that might not sound encouraging at first glance: creatives have something that you and I will never have – creative talent, training and the discipline to make a living doing their art.

That alone makes them precious to the Christian church. God has given them gifts and those gifts make them gifts to us! Creatives are *necessary* gifts from God to his church as it exists and persists before a watching world.

Knowing that creatives are gifted in a way that the rest of us are not could provoke all sorts of responses. It might provoke envy ('Why do they get all the luck?'). It might provoke disdain ('Why don't they get a *real* job and earn an honest living like the rest of us?'). It might even provoke a bit of schadenfreude whenever we see one stumble ('Hah! Knew it. They're just phonies!').

None of these responses treats Christian creatives with the respect and love that we owe these brothers and sisters in Christ.

But I get it. Let's be frank – a lot of creative people are just kind of . . . weird. Don't get me wrong, they're lovely people, but they can be a *lot* to handle.

For one, they tend to be passionate. They feel strongly about things. And being by nature expressive people, they are ready to voice (or paint or sing or write) their strong opinions.

Not only are they passionate but they are also *different*. Their brains are just wired differently. They see differently, sense different wavelengths, process thoughts differently. They notice different things. I've heard cat owners talk about how their cats just stare at what looks like an empty corner of the room, like they see something the rest of us can't. It's sort of like that. They have sensitivities to things that we might find hard to perceive, much less understand.

That's a good thing, but there is a downside to this creative sensitivity as well. There are studies that link artistic creativity with a host of psychological disorders (though we need to be careful not to play into the Romantic stereotype of the 'tortured genius' here).[4] That's not to say *every* creative struggles with depression, anxiety, bipolar disorder, borderline personality disorder (BPD) or some other mental health issue. It's also not to say that every person struggling with a mood disorder has a trapped creative genius deep inside. But the correlation is there (my own artistically gifted daughter struggled with BPD for years).

That is to say, creative people are not only creative; they can be deeply broken people as well. I want to be quick to add that my dear co-author, Ruth, is one of the most sane, down-to-earth people I know – there's always a danger of overgeneralizing. But many creatives *are* broken and struggling in ways that make them difficult to deal with. They need mercy and support more than anything.

In other words, not only does the church need creatively gifted people but creatives also need the church.

Let me say it again: They. Need. Us.

Those who make their living in the arts and entertainment industry need grounded non-artist friends. They need brothers- and sisters-in-arms who may not do art for a living, but understand the world they live in, the temptations they face, the pressures they feel and the way their career has an impact on their lives.

Artists often lack what you and I take for granted: a steady income. They face the psychological strain of perpetual financial insecurity. It's a weight that can grind them down.

More than financial insecurity, creatives often feel deeply insecure about their own creativity. They're squirrelly that way. They have the unshakeable impression that their identity and self-worth hang on whatever work they happen to be doing at the moment, and if that's done, then it hangs on their *next* project. They pour themselves out into their work over and over again and it drains them. And then,

that work is either well received or criticized. And then they do it all over again.

It's a rough way to live, a rough place to maintain a bit of spiritual sanity. They need to be reminded of the grace and security found in the gospel again and again. They need prayer. They need encouragement.

They. Need. Us.

And . . .

We. Need. Them.

In a world convinced that Christians are either boring or toxic, we need those who can plant oases. We need bridge-builders. We need magicians who can pull away the handkerchief from the top hat and show us wonders that will blow our minds. We need jewellers who can carve the gem of faith and show us facets we'd overlooked, light refracted into a billion colours, dazzling, dancing all around us.

Consider for a moment the joy we get from having our imaginations expanded by the work of artists. Consider the chills that run down your spine when you hear part of a song that hits just right. Consider the awe you feel at the twists and turns of a story well told. Consider the consolation you get from a hope that's real and runs deep displayed, luminous, in a cinema or on a television screen.

The arts and entertainment aren't just fun. In a dark world where life is hard and often disappoints, these things can expand our minds, open our eyes to see reality and help us to rally and press on the way that Jesus bids us to. These things can draw those who have long rejected God, the cynical and wounded, into wonder.

This whole book has been one long plea to recognize one simple fact: we need one another.

So this is my word of encouragement to all of us to love – tangibly, practically – the artistically creative among us. It's time for us to give them support that they can feel. It's time to express our gratitude to God for these gifts he's given us – broken but healing, creative but needy.

This is your family. Enjoy it.

Christians of the world, unite! You have nothing to lose . . . and a world to win.

Notes

1 Madeleine L'Engle, *Walking on Water: Reflections on faith and art* (Wheaton, IL: Harold Shaw, 1980), p. 70.

2 This is also the famous beginning of the Westminster Shorter Catechism (1647).

3 Charles H. Spurgeon, Sermon: 'All for Jesus' (29 November 1874), *Metropolitan Tabernacle Pulpit*, Volume 20 (London: Forgotten Books, 2018), <www.spurgeon.org/resource-library/sermons/all-for-jesus/#flipbook>, accessed March 2023.

4 See, for instance, Nadra Nittle, 'The link between depression and creativity', *Very Well Mind* (20 February 2023), <www.verywellmind.com/the-link-between-depression-and-creativity-5094193>, accessed March 2023.

Further reading

A book that says a lot of what this book says, with more detail, case studies and footnotes

Ted Turnau, *Oasis of Imagination: Engaging our world through a better creativity* (London: IVP, 2023).

Books about Christian cultural engagement

Crouch, Andy, *Culture Making: Recovering our creative calling* (Downers Grove, IL: InterVarsity Press, 2008).

Fujimura, Makoto, *Culture Care: Reconnecting with beauty for our common life* (Downers Grove: InterVarsity Press, 2017).

Miller, Paul D., *The Religion of American Greatness: What's wrong with Christian nationalism* (Downers Grove, IL: IVP Academic, 2022).

Romanowski, William D., *Eyes Wide Open: Looking for God in popular culture* (Grand Rapids, MI: Brazos Press, rev. exp. ed., 2007).

Turnau, Ted, *Popologetics: Popular culture in Christian perspective* (Phillipsburg, NJ: P&R, 2012).

Turnau, Ted, Burnett, E. Stephen and Moore, Jared, *The Pop Culture Parent: Helping kids engage their world for Christ* (Greensboro, NC: New Growth Press, 2020).

Turner, Steve, *Popcultured: Thinking Christianly about style, media and entertainment* (Nottingham: IVP, 2013).

Books about the imagination

Davies, Jim, *Imagination: The science of your mind's greatest power* (New York: Pegasus Books, 2019).

Guite, Malcolm, *Lifting the Veil: Imagination and the kingdom of God* (Baltimore, MD: Square Halo Books, 2021).

Ryken, Leland (ed.), *The Christian Imagination: The practice of faith in literature and writing* (Colorado Springs, CO: Shaw Books, rev. exp. ed., 2002).

Smith, James K. A., *Imagining the Kingdom: How worship works*, Cultural Liturgies, Volume 2 (Grand Rapids, MI: Baker Academic, 2013).

Books about art and creativity

Brand, Hilary H. and Chaplin, Adrienne, *Art and Soul: Signposts for Christians in the arts* (Downers Grove, IL: InterVarsity Press, 2001).

Fujimura, Makoto, *Art and Faith: A theology of making* (New Haven, CT, and London: Yale University Press, 2020).

Gordon, Alastair, *Why Art Matters: A call for Christians to create* (London: IVP, 2021).

L'Engle, Madeleine, *Walking on Water: Reflections on faith and art* (Wheaton, IL: Harold Shaw, 1980).

O'Connor, Flannery, 'Writing short stories' in Sally and Robert Fitzgerald (eds), *Mystery and Manners: Occasional prose* (New York: Noonday Press, 1969).

Ryken, Leland, *Art for God's Sake: A call to recover the arts* (Phillipsburg, NJ: P&R, 2006).

Seerveld, Calvin, *Bearing Fresh Olive Leaves: Alternative steps in understanding art* (Carlisle and Toronto, Ontario: Toronto Tuppence Press and Piquant, 2000).

Seerveld, Calvin, *Rainbows for the Fallen World: Aesthetic life and artistic task* (Toronto, Ontario: Toronto Tuppence Press, 2005 [1980]).

Turner, Steve, *Imagine: A vision for Christians in the arts* (Downers Grove, IL: InterVarsity Press, 2001).